POSTCARD HISTORY SERIES

The Wildwoods

IN VINTAGE POSTCARDS

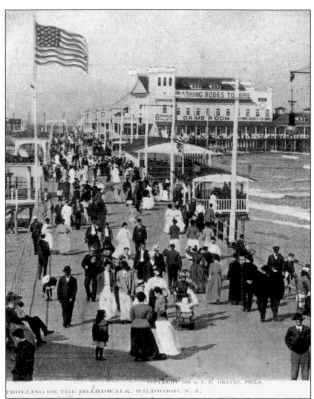

STROLLING ON THE BOARDWALK. The first permanent boardwalk in the Wildwoods was installed in time for the 1900 summer season. Since its inception, the boardwalk has undergone numerous reconstructions, extensions, and on occasion has even been moved farther east as the beaches expanded. Even though the boardwalk has constantly changed and evolved, it has never ceased to thrill, amaze, entertain, enlighten, delight, and bring pleasure to those who seek to stroll the boards. Almost anyone who experiences the boardwalk will have memories to last a lifetime. (C. Graves, 1906.)

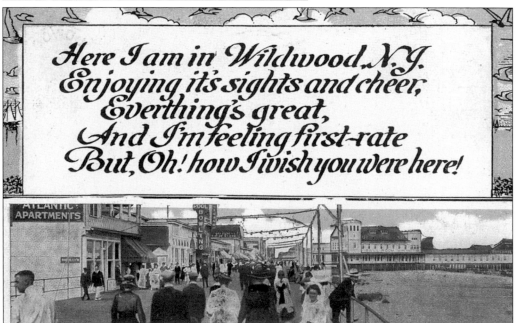

Here I am in Wildwood, N.J.
Enjoying it's sights and cheer,
Everthing's great,
And I'm feeling first-rate
But, Oh! how I wish you were here!

GREETINGS. A postcard was an inexpensive way of conveying to family and friends at home the enjoyment one was having vacationing at the shore. The sentiments expressed on the front of this postcard have been shared by millions of visitors to the Wildwoods over the years. "Oh! How I wish you were here!" (Publisher unknown, *c.* 1920.)

POSTCARD HISTORY SERIES

The Wildwoods
IN VINTAGE POSTCARDS

James D. Ristine
Foreword by Robert J. Scully Sr.

ARCADIA

First published 2002
Reprinted 2004

Published by Arcadia Publishing,
Charleston SC, Chicago IL, Portsmouth NH, San Francisco CA

Printed in Great Britain

Library of Congress Catalog Card Number: 2002100073

For all general information, contact Arcadia Publishing:
Telephone 843-853-2070
Fax 843-853-0044
E-mail sales@arcadiapublishing.com
For customer service and orders:
Toll-free 1-888-313-2665

Visit us on the Internet at www.arcadiapublishing.com

I would like to dedicate this book to my
father, Edward J. Ristine. He spent many of his
childhood summers vacationing in Wildwood
Crest and would often relate stories to me
about those happy days. He helped instill in
me a love and appreciation for the wonders of
the New Jersey shore. This photograph, taken
in 1922, shows my father at age 10 proudly
displaying a flounder he caught in local waters.

CONTENTS

FOREWORD

Over the years, much of the physical appearance of the Wildwoods has changed, but when we view postcard images from the past that depict the beach, boardwalk, buildings, harbors, and streets, we come to realize that not all things change.

In the early 1900s, the communities of Holly Beach and Wildwood were beginning to develop into health and entertainment resorts. Vacationers came for the beach, ocean, fishing, and dancing. Hotels, dining rooms, and ballrooms competed for clients. Sending a postcard back home to the family let everyone know where you were and what you saw. A wife to her husband, a son to his mother and father, a cousin to the family—most cards contained the familiar line "Having a great time, wish you were here." The enjoyment of the tourists was reflected in the messages and cards they sent.

In 1909, over one million postcards passed through the island's post offices. These cards sent messages to many cities in the United States and various foreign countries, spreading the word about the Wildwoods. The scenes shown on the cards reflected the entire community. Every imaginable building, tree, or comic theme was included in the publisher's list of available cards. These postcards give us a visual reminder of our past, and the pictorial history and loving messages they carried bring to life the spirit and family unity of those who sent them.

The author of this book has selected more than 230 vintage postcard images to tell the story of the Wildwoods. So, look, read, and enjoy.

—Robert J. Scully Sr.
Curator, Wildwood Historical Society Museum

INTRODUCTION

The Wildwoods are situated on an island known as Five Mile Beach, near the southern tip of New Jersey's 127-mile-long coastline. The communities of North Wildwood (formerly Anglesea), Wildwood, Holly Beach, and Wildwood Crest have been luring visitors and vacationers to their shores for nearly 120 years.

The first to enjoy the bounty of the Wildwoods were the Native Americans known as the Lenni Lenape, who hunted and fished here. Later, during the 1870s, fishermen established the community of Anglesea on the northern tip of the island. In the 1880s, the true settlement of the area began. Holly Beach, in the center of the island, and Anglesea, to the north, were officially incorporated in 1885. Wildwood's incorporation was in 1895, and Wildwood Crest followed in 1910, the same year that Anglesea officially became North Wildwood. Much of this development was due to the work and promotion by the three Baker brothers. Philip P. Baker, Latimer R. Baker, and J. Thompson Baker played pivotal roles in the evolution of the Wildwoods. In 1912, through their efforts and that of others, the communities of Holly Beach and the borough of Wildwood had grown to the extent that the city of Wildwood was created when the two merged. By this time, the area had become a noted seaside resort attracting multitudes of visitors.

This book focuses on the time period from 1900 to 1925, an era that corresponds with this great transformation. An attempt will be made to shed light on the people, places, and events that helped shape this evolution. Revisited are the days when the Wildwoods lived up to their name, with their stands of tall trees and thick vegetation. There was a time when strolling the beach or walking the boardwalk meant wearing your finest attire, and swimming in the ocean required the donning of long woolen or flannel swimwear. Commercial fishermen once launched their skiffs directly from the ocean beaches, and the docks of Anglesea were crowded with fishing craft of all types. The Wildwood communities were to see dramatic changes as they developed into bustling resorts. Much of what is documented in this book is now lost to history. Majestic hotels such as the Edgeton Inn, the Greylock, and Wildwood Manor have all disappeared, as well as unique homes and cottages such as the Hollies, the Garden of Eden, and Castlereagh. Many of these were lost to fire. Others succumbed to urban development. Even the streets themselves have been transformed, as some thoroughfares have been removed, others have been created, and still others have undergone name changes. The great amusement piers such as Crest Pier, Ocean Pier, and the Casino, which once attracted vast numbers of entertainment seekers, are now gone. The ever-changing face and evolution of the boardwalk are documented in the picture postcards shown on the pages of this book. A look back is also taken at the great celebrations, festivities, an

events that thrilled our ancestors: baby parades, Fourth of July fireworks, automobile races through the streets, balloon ascensions, yacht races, and airplane rides on the beach.

The time period covered by this book is known to postcard collectors as the golden age. Since its inception in the United States in 1893, the picture postcard has served as an inexpensive souvenir and as an easy way to send a thought or remembrance to a friend or loved one. During these early years, quite a number of publishers produced postcard images promoting the wonders and sights of the Wildwoods. This included such local businesspeople and entrepreneurs as George E. Mousley, William H. Iszard, John Martin, A. Wilson, Charles Mace, and Philip Gould. John Reeve's Wildwood Post Card Company was a major producer of images from the very beginning. Premier publisher R. W. Ryan used printing companies in Germany, France, and other places to print his vast variety of postcards. Later in the 1920s, cards put out by Lynn H. Boyer and John C. Funck became commonplace. For the benefit of postcard collectors, I have included (when known) the name of the publisher and the date or estimated date of publication.

My goal is to provide a unique and fascinating glimpse into the past of the Wildwoods by using photographic images provided to us by the postcard publishers of the early 20th century.

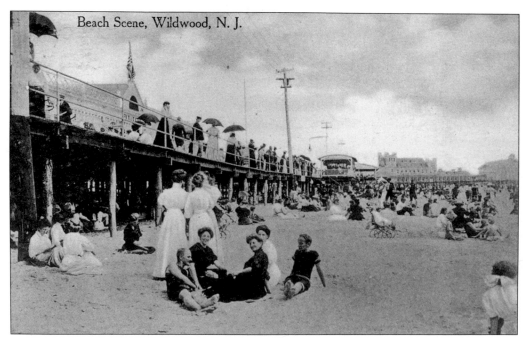

A BEACH SCENE. In the early 1900s, picture postcards such as this cost only 1¢ or 2¢. Postage was only an additional cent. During that time, these photographic images served as a means of communication or as inexpensive souvenirs. Today, these same postcards are a visual record of the social, cultural, and architectural history of the Wildwoods. (R. W. Ryan, *c.* 1908.)

One

NORTH WILDWOOD
(ANGLESEA)

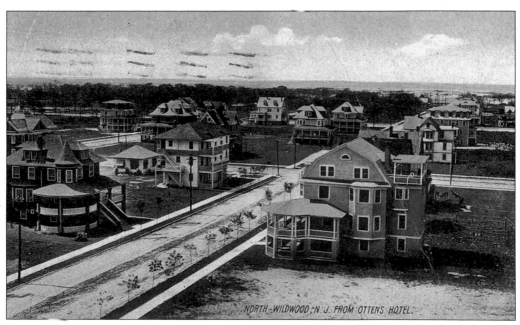

NORTH WILDWOOD, FROM THE OTTENS HOTEL. Located at the northern end of Five Mile Beach, this community was originally given the name of Anglesea. First settled as a small fishing village in the 1870s, it would eventually extend south from the inlet to 26th Avenue. In 1910, it officially became the city of North Wildwood. (R.W. Ryan, *c.* 1908.)

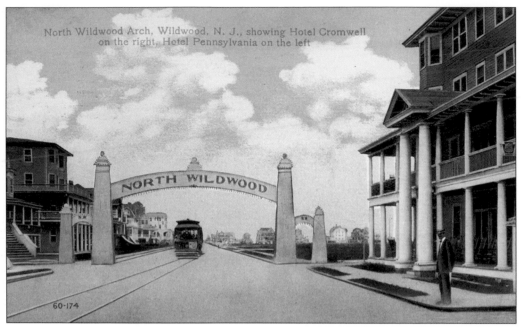

THE NORTH WILDWOOD ARCH. The southern entrance to North Wildwood at 26th and Atlantic Avenues was marked by a Roman-style arch that spanned the street. Built in 1911 by Charles Glen, the large cement arch had electric lights installed for illumination at night. An arch of similar style was constructed by the same builder at the entrance to Wildwood Crest. (R.W. Ryan, 1912.)

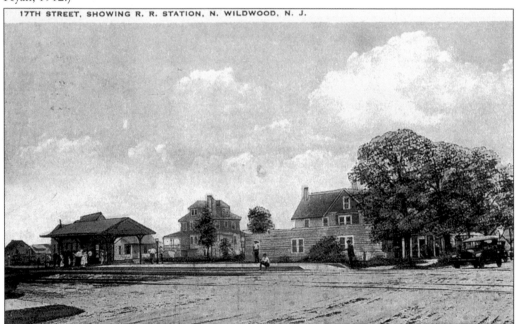

THE 17TH AVENUE RAILROAD STATION. This small railroad station at 17th and New Jersey Avenues was the receiving and departure point for countless vacationers over the years. Until the mid-1920s, the railroad typically carried more passengers to the Wildwoods than did automobiles. (Lynn H. Boyer, c. 1919.)

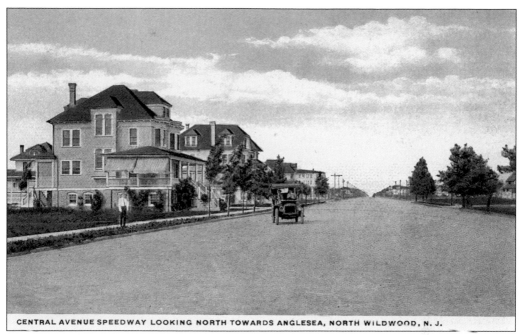

CENTRAL AVENUE SPEEDWAY LOOKING NORTH TOWARDS ANGLESEA, NORTH WILDWOOD, N. J.

THE SPEEDWAY. Running through the heart of North Wildwood, Central Avenue was also known as "the speedway." Providing a 2-mile-long, 80-foot-wide straightaway, it was to serve as the site of numerous automobile races. Held under the auspices of the North Wildwood Automobile Club, the first races were held in 1907. (John C. Funck, *c.* 1919.)

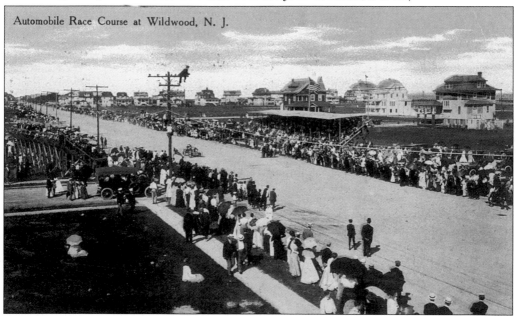

Automobile Race Course at Wildwood, N. J.

THE AUTOMOBILE RACECOURSE. The racing season would open on the Fourth of July and draw huge numbers of excited spectators. In 1908, one race alone was witnessed by an estimated 20,000 people. That year, a total of 100,000 were said to have attended the races. Grandstands were erected along the course, but this did not stop some people from climbing telephone poles to get a better look at the racers. (George E. Mousley, 1910.)

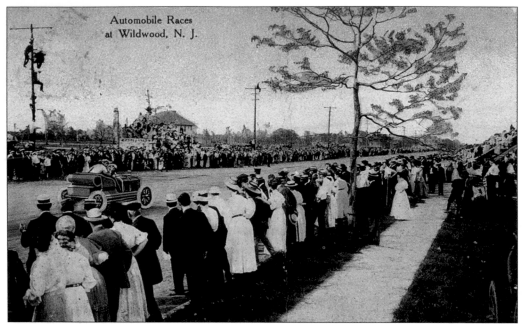

Automobile Races
at Wildwood, N. J.

THE AUTOMOBILE RACES. These immensely popular competitions drew widespread fame. One newspaper article in 1908 stated, "These races are noted throughout America and in the European press and are becoming events of international character." A race in 1910 was won when pilot (as drivers were called at the time) Charles Warren sped across the finish line at a speed of 59 miles per hour. (George E. Mousley, *c.* 1910.)

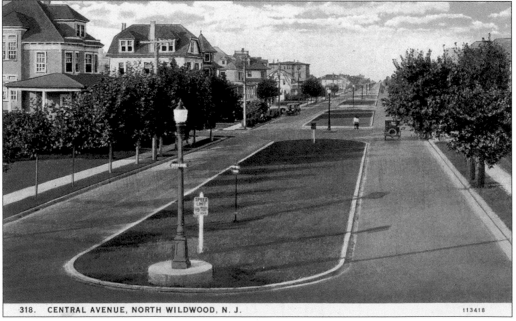

318. CENTRAL AVENUE, NORTH WILDWOOD, N. J. 113418

CENTRAL AVENUE. When automobile races were no longer held in the streets of North Wildwood, Central Avenue was divided. Curbed, grassy median dividers were put in place. With a posted speed limit of 15 miles per hour, times had certainly changed. This beautiful avenue remains divided this way even today. (C.T. American, *c.* 1922.)

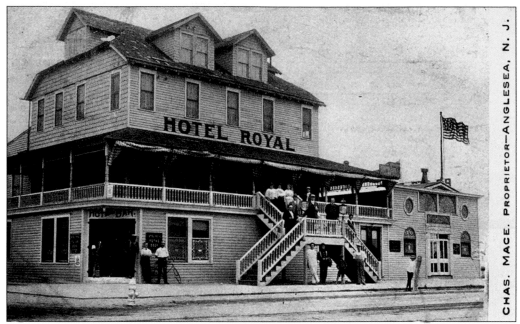

THE HOTEL ROYAL. Standing on the corner of Spruce and New Jersey Avenues, the Hotel Royal was opened in June 1894 with 18 rooms available. Owned by Charles Mace, the building had 100 feet of porch adjoining the Royal Garden, where music and, later, motion pictures helped entertain guests. The hotel was popular with fishermen due to its close proximity to Mace's Pier and the docks. (Douglass Post Card Company, *c.* 1908.)

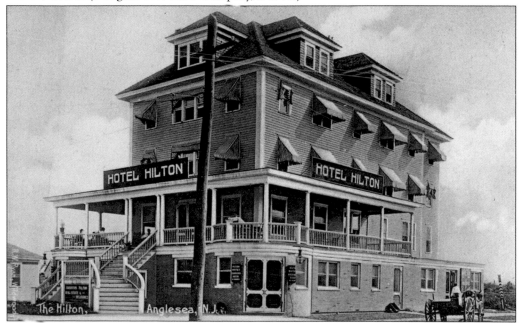

THE HOTEL HILTON. This hotel, owned by F.M. Toppin, was located opposite the North Wildwood train station. Steam heated, the hotel welcomed guests year-round. Its broad verandas provided views overlooking the ocean, and its first floor contained an up-to-date cafe. (R.W. Ryan, *c.* 1907.)

13

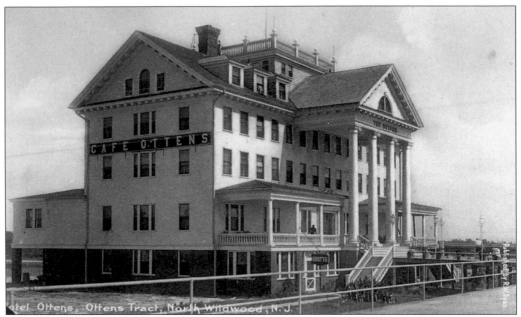

THE HOTEL OTTENS. Built by Goslin and Brannon, this hotel at 18th and Surf Avenues first opened its doors on July 2, 1904. With rooms arranged singly and en suite with tiled baths, the Ottens offered all the comforts conducive to health and pleasure. A fire ravaged the structure on May 2, 1919. (R.W. Ryan, *c.* 1906.)

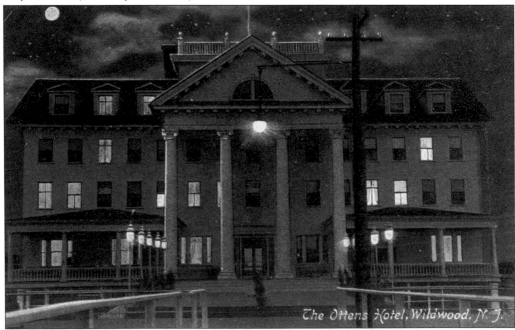

THE HOTEL OTTENS AT NIGHT. Often open all year, this hotel had much to offer its clientele. Besides easy access to the boardwalk, the Ottens had many indoor attractions to occupy its guests. These included a large general assembly room, a well-appointed buffet, a replica of a German rathskeller, and a full orchestra to play for dances held in the ballroom. (Illustrated Postal Card Company, *c.* 1909.)

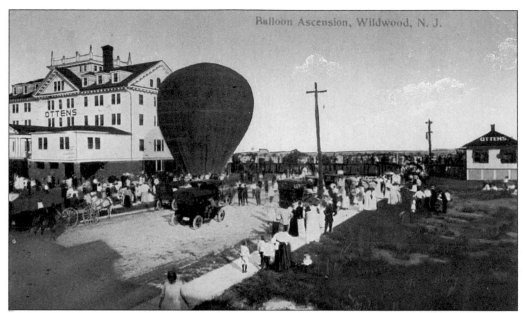

A BALLOON ASCENSION. Alongside the Hotel Ottens, a hot-air balloon is being inflated and prepared for ascension. Some of the aerial photographs taken during its flight may have been used to produce the bird's-eye-view postcards of the Wildwoods seen in this book. In any event, the balloon launch must have surely generated some excitement for the spectators. (John Martin, c. 1910.)

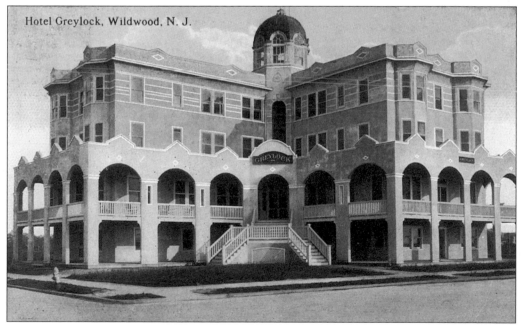

THE HOTEL GREYLOCK. A very impressive building for its time, the Hotel Greylock was situated at the corner of 23rd and Atlantic Avenues. Advertised as the Wildwoods' first fireproof hotel, it ironically burned to the ground in a devastating fire in February 1919. (George E. Mousley, c. 1910.)

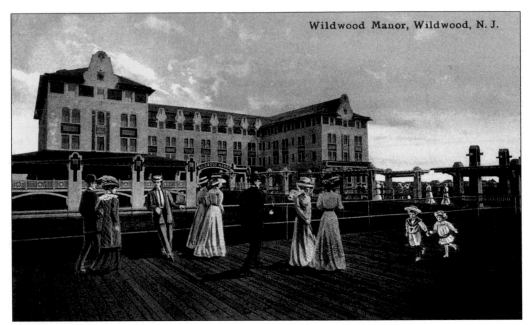

WILDWOOD MANOR. The largest hotel in the Wildwoods, Wildwood Manor opened in 1907 and occupied an entire square of ocean frontage between 24th and 25th Avenues. It was built in the typical majestic architectural style of its day at a cost of $200,000. A long walkway extending from the hotel provided easy access to the boardwalk. (George E. Mousley, *c.* 1910.)

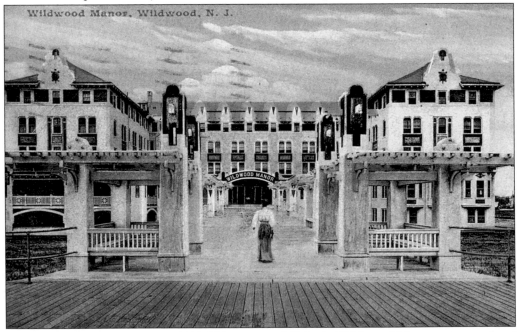

ELEGANT ACCOMMODATIONS. With 200 rooms and 50 baths, Wildwood Manor accommodated those wishing to experience a more elegant style of vacation. Woodrow Wilson stayed here on four occasions. His last visit, on October 30, 1912, was just six days before his election as president of the United States. In 1968, this renowned hotel was destroyed by fire, a fate shared by many landmark hotels. (R.W. Ryan, *c.* 1908.)

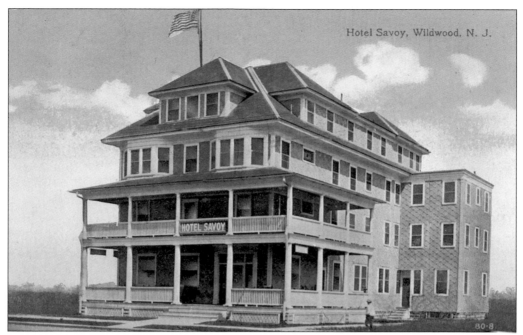

THE HOTEL SAVOY. The Savoy, owned by W.H. Gerstel, was open only during the extended summer season, from the beginning of June to October. Situated at 26th and Atlantic Avenues, it was only a short distance to the beach and boardwalk. The hotel could house up to 200 guests. (R.W. Ryan, *c.* 1914.)

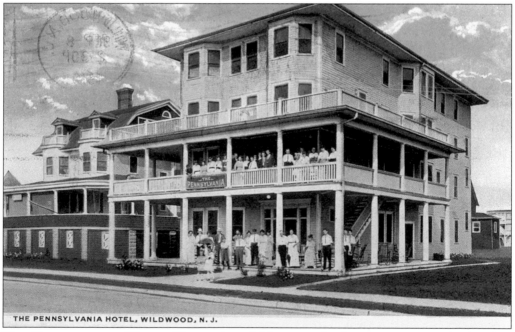

THE PENNSYLVANIA HOTEL. The sender of this postcard, who was a guest at the hotel in September 1915, writes to a friend, "This is a very fine place indeed." Standing at 26th and Atlantic Avenues, the Pennsylvania Hotel was later destroyed by a fire that started in its kitchen. (Post Card Distribution Company, *c.* 1913.)

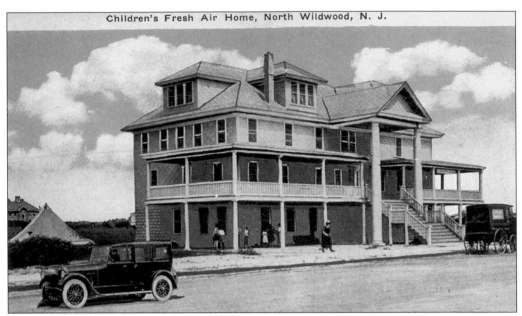

THE CHILDREN'S FRESH AIR HOME. In 1911, Ida Dukes of Camden began bringing children from the city to North Wildwood to vacation. Eventually, her organization moved to this location at 11th and Surf Avenues. This particular building was constructed on land donated to the organization by Henry Ottens. (John C. Funck, *c.* 1920.)

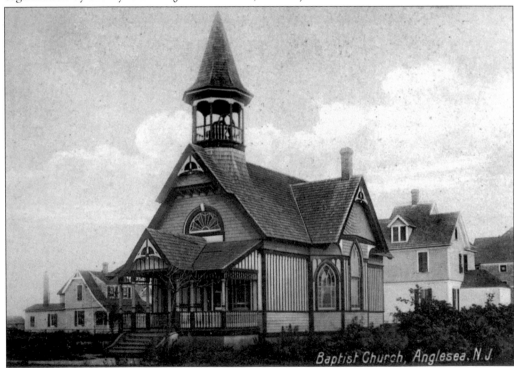

A BAPTIST CHURCH. The Baptists organized numerous congregations and had a strong religious presence in early Cape May County. In March 1898, this Baptist church was constructed at 3rd and Pennsylvania (now Atlantic) Avenues. (R.W. Ryan, *c.* 1908.)

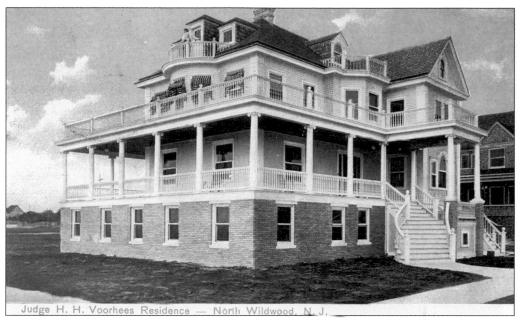

Judge H. H. Voorhees Residence — North Wildwood, N. J.

THE VOORHEES RESIDENCE. This stately home, designed with a bricked first floor and extensive porch with Roman-style columns, still stands near the corner of 24th and Atlantic Avenues. The house was once the residence of Judge H.H. Voorhees. (Wildwood Post Card Company, *c.* 1910.)

RESIDENCE ON 24TH AVENUE, WILDWOOD, N. J.

MACE'S HOSPITAL. This magnificent house at 2410 Atlantic Avenue was originally the home of Frederick Sutton. Sutton, a prominent local businessman and bank director, lost his life in the sinking of the *Titanic*. On April 1, 1915, the home became Mace's Hospital, where Dr. Margaret Mace for 35 years treated all those who needed medical care. The building was later torn down. (National Post Card Company, *c.* 1915.)

19

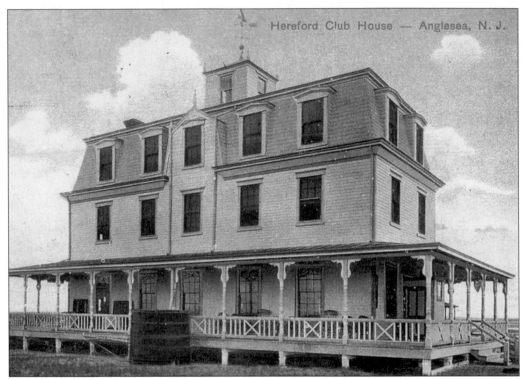

THE HEREFORD CLUBHOUSE. This wooden three-story building was located at Walnut and Pennsylvania (now Atlantic) Avenues, overlooking the Hereford Inlet. It served as a men's social and fishing club at the northern tip of the island. (Wildwood Post Card Company, *c.* 1908.)

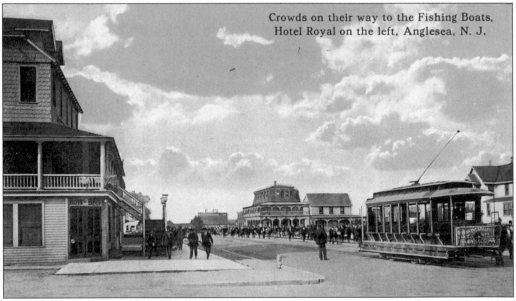

Crowds on their way to the Fishing Boats, Hotel Royal on the left, Anglesea, N. J.

ON THE WAY TO THE FISHING BOATS. These men walk down the street in a long procession, passing the Hotel Royal on their right, as they head for the fishing docks. Anglesea (North Wildwood) was a renowned fishing destination during the early 1900s. The railroad ran special fishing excursions, which brought fishermen in by the trainload. (William H. Iszard, *c.* 1914.)

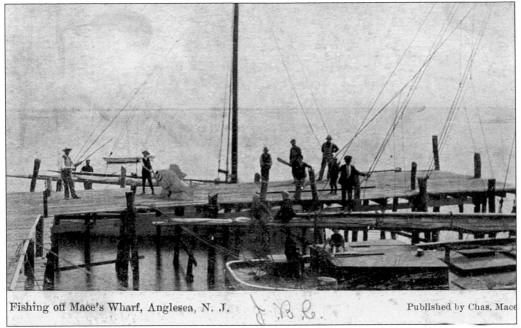

Fishing off Mace's Wharf, Anglesea, N. J. J. B. C. Published by Chas. Mace

FISHING OFF MACE'S WHARF. At the end of New Jersey Avenue, where it meets the inlet, stood Mace's Wharf. The pier provided not only dockage space for a number of fishing vessels but also a place for people to walk out and drop a line into the inlet in hopes of catching a fish or two. (Charles Mace, *c*. 1906.)

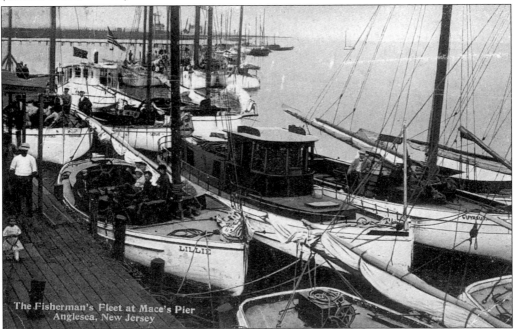

The Fisherman's Fleet at Mace's Pier
Anglesea, New Jersey

THE FISHERMEN'S FLEET AT MACE'S PIER. Mace's Pier was the docking location for a number of commercial fishing vessels. These boats would journey to offshore fishing grounds, including the Five Fathoms Bank, to harvest a wide variety of fish species. A local census taken in 1916 reported that 486 men were employed in the fishing industry. (R.W. Ryan, *c*. 1911.)

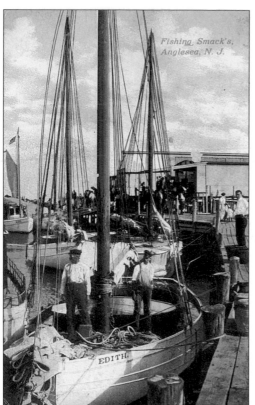

Fishing Smack's, Anglesea, N. J.

EDITH.

FISHING SMACKS. Tied up to a crowded dock, the fishing vessel *Edith* is only one of many commercial boats that called Anglesea its home port. These single-masted sailing craft were equipped with large circular tanks to hold their catch until it could be off-loaded at the wharf. In 1914, more than 100,000 pounds of fish were shipped from North Wildwood. (John Martin, *c.* 1910.)

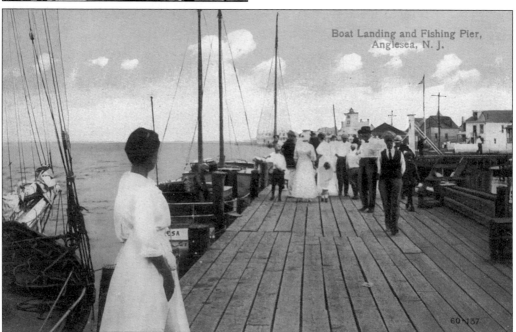

Boat Landing and Fishing Pier, Anglesea, N. J.

THE BOAT LANDING AND PIER. Curiosity about the day's catch often brought the public down to the docks. Here, people might spend part of their afternoon casually strolling along the wharf and checking out the activity in and around the boats moored to the pier. (R. W. Ryan, 1912.)

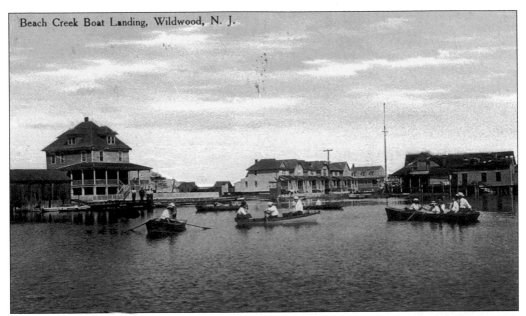

Beach Creek Boat Landing, Wildwood, N. J.

THE BEACH CREEK LANDING. Several boats row around at the mouth of Hoffman Canal, which opened on the Intercoastal Waterway. In the background is what was commonly referred to as the Beach Creek boat landing. This was in the days before the outboard motor, when pulling on a pair of oars was the means by which to propel a craft over the bay's waters. (George E. Mousley, *c.* 1910.)

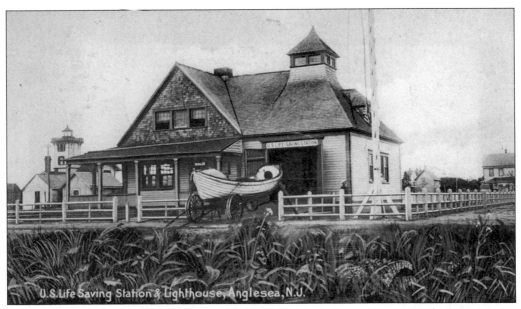

U.S. Life Saving Station & Lighthouse, Anglesea, N.J.

A U.S. LIFESAVING STATION. Erected in the 1890s as a station of the U.S. Lifesaving Service, this building later became a Coast Guard station. Situated at Walnut and Central Avenues, it stood within sight of the inlet. Hereford Inlet Station No. 133 was originally staffed with seven crewmen and one surf boat. The building is still standing near the lighthouse. (R.W. Ryan, *c.* 1906.)

23

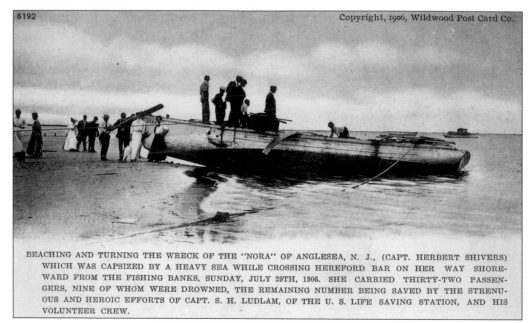

BEACHING AND TURNING THE WRECK OF THE "NORA" OF ANGLESEA, N. J., (CAPT. HERBERT SHIVERS) WHICH WAS CAPSIZED BY A HEAVY SEA WHILE CROSSING HEREFORD BAR ON HER WAY SHORE-WARD FROM THE FISHING BANKS, SUNDAY, JULY 29TH, 1906. SHE CARRIED THIRTY-TWO PASSENGERS, NINE OF WHOM WERE DROWNED, THE REMAINING NUMBER BEING SAVED BY THE STRENU-OUS AND HEROIC EFFORTS OF CAPT. S. H. LUDLAM, OF THE U. S. LIFE SAVING STATION, AND HIS VOLUNTEER CREW.

THE WRECK OF THE *NORA*. Returning from the fishing banks on July 29, 1906, the vessel *Nora* sank due to heavy seas in the inlet. Of the 32 passengers, 9 drowned in the capsizing. A U.S. Lifesaving Service crew, under Capt. S.H. Ludham, participated in the rescue. Here, the boat is shown being beached and righted. (Wildwood Post Card Company, 1906.)

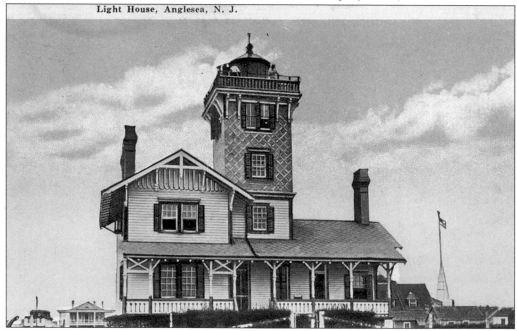

Light House, Anglesea, N. J.

THE HEREFORD INLET LIGHTHOUSE. Looking out over the mouth of the Hereford Inlet, this lighthouse, designed by Paul J. Pelz, was built in 1874. The Victorian-style lighthouse had a beam visible for a distance of 13 nautical miles. In 1914, the structure was moved 150 feet westward to where it stands today. Located near First and Central Avenues, it was restored in the late 1990s and is now a museum. (Publisher unknown, *c.* 1920.)

Two

WILDWOOD,
CITY BY THE SEA

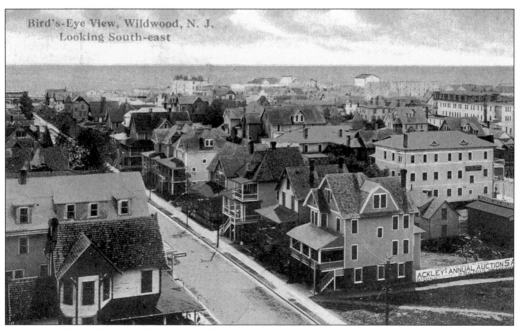

Bird's-Eye View, Wildwood, N. J.
Looking South-east

ACKLEY'S ANNUAL AUCTION SA

A BIRD'S-EYE VIEW. This postcard, postmarked in July 1911, gives a view looking to the southeast. In 1912, the borough of Wildwood merged with Holly Beach, the older community to its south, to become the city of Wildwood. A sign advertising Ackley's annual real estate auction is seen in the lower right of this picture. John A. Ackley was one of the more prominent realtors of the time. (R.W. Ryan, *c.* 1911.)

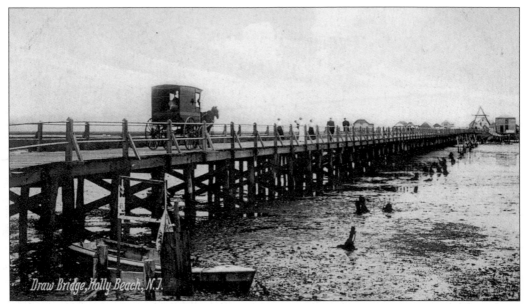

Draw Bridge, Holly Beach, N.J.

THE DRAWBRIDGE. This view shows the old wooden drawbridge that was built at what is now Rio Grande Avenue. The span connected the island of Five Mile Beach to the mainland. A trail that allowed Native Americans access to the island for hunting and fishing existed in this area. (R.W. Ryan, *c.* 1908.)

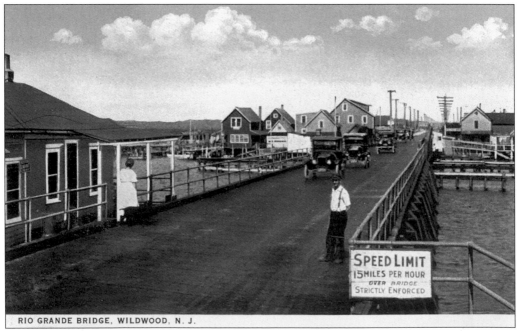

RIO GRANDE BRIDGE, WILDWOOD, N. J.

THE RIO GRANDE BRIDGE. Pictured here is the bridge that was constructed to replace the older wooden span. The new two-lane bridge allowed easier access by automobiles, which were becoming more commonplace, and helped attract larger numbers of visitors to the island. Before this, it was the railroad that reigned supreme in transporting people to the Wildwoods. (John C. Funck, *c.* 1915.)

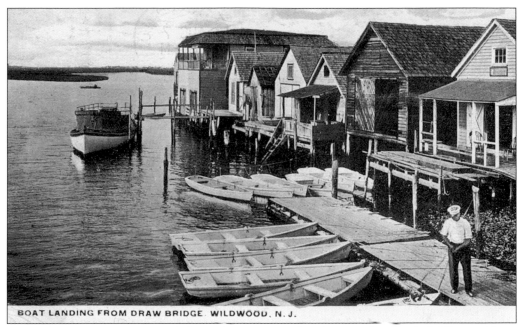

BOAT LANDING FROM DRAW BRIDGE. WILDWOOD. N. J.

A Boat Landing. A man carefully tends to a string of rowboats tied to the dock. Those wishing to fish or crab in the back waters of Wildwood could rent a boat from this boat landing. These small wooden buildings along the waterfront were located just north of the Rio Grande Bridge. (A. Wilson, *c.* 1918.)

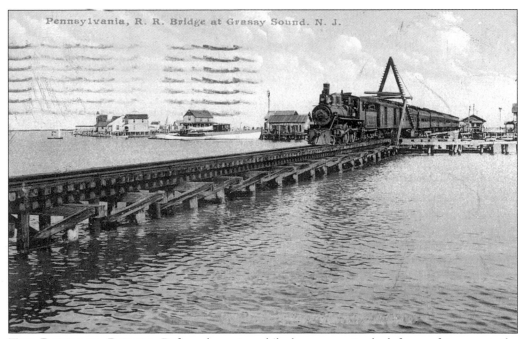

Pennsylvania, R. R. Bridge at Grassy Sound. N. J.

The Railroad Bridge. Before the automobile became a standard form of transport, the railroad carried most people to the Wildwoods. Trains would use this railroad bridge to traverse the body of water known as Grassy Sound, which separates the island from the mainland. In 1903, as many as 16 trains a day would pull into the Grassy Sound Station. (R. W. Ryan, *c.* 1908.)

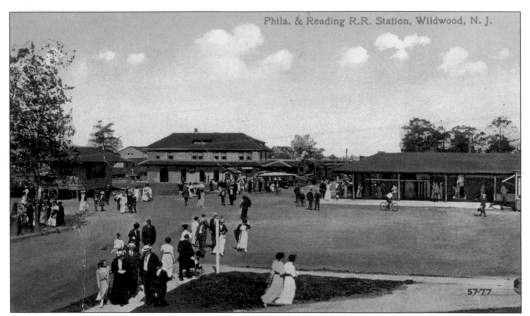

WILDWOOD'S RAILROAD STATION. The railroads were instrumental in opening the New Jersey seaside resorts to tourism in the early 1900s. During the summer months, trains running from Philadelphia would bring visitors by the thousands to the Wildwoods. Here, we see some of the hectic comings and goings at the Pennsylvania and Reading station. (R.W. Ryan, *c.* 1914.)

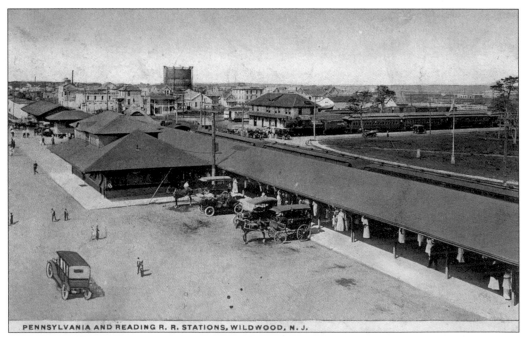

THE PENNSYLVANIA AND READING STATION. Situated at Oak and New Jersey Avenues was the large Pennsylvania and Reading Railroad station. The railroad attempted to increase passenger service to Philadelphia by advertising that a trip to the city would take only 90 minutes. With a covered platform extending three blocks, the station offered every convenience to its patrons. (John C. Funck, *c.* 1919.)

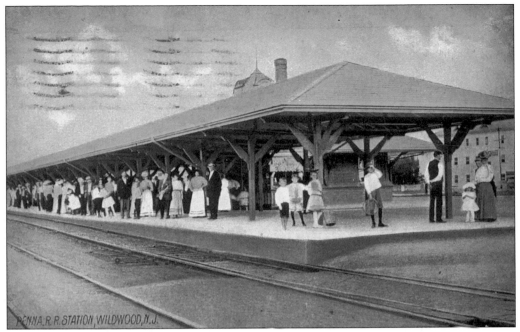

THE PENNSYLVANIA RAILROAD STATION. In this view, people are seen awaiting the arrival of the next train. On one weekend in 1904, more than 4,000 passengers disembarked at this depot, and the total for the season was said to be 75,000 riders. Some 20,000 riders arrived on a single summer day in 1905. By the 1950s, service was minimal and, in 1958, only two trains per day ran in the winter. (R.W. Ryan, *c.* 1908.)

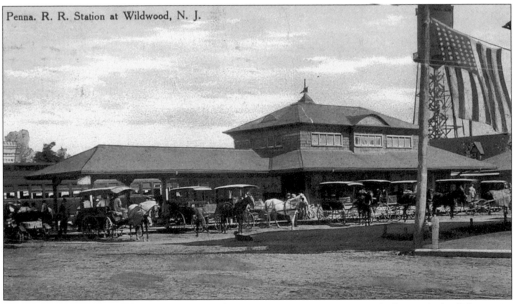

THE PENNSYLVANIA STATION. Horse-drawn passenger carriages await the arrival of the train. Perhaps these conveyances were sent by the hotels to pick up patrons and their baggage and transport them to their accommodations. In 1908, the Hotel Ruric used an electric bus to meet its guests at the station. (George E. Mousley, *c.* 1910.)

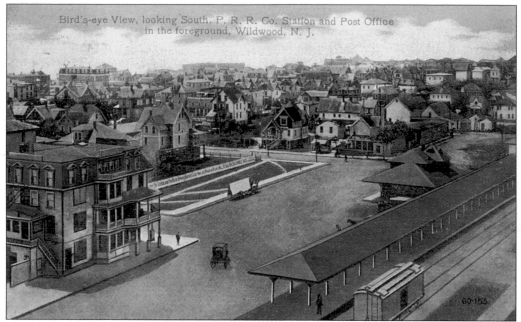

A BIRD'S-EYE VIEW. The Pennsylvania and Reading Railroad station is seen on the right in this view looking south. Across the street is the Fenwick Hotel, where Wildwood's second post office was located. Other than a lone, horse-drawn wagon heading down the center of the thoroughfare, the area is unusually void of activity. (R.W. Ryan, 1912.)

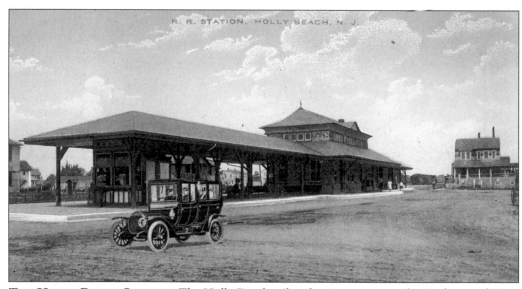

THE HOLLY BEACH STATION. The Holly Beach railroad station once stood at Andrew and New Jersey Avenues. During the summer season, this depot handled many thousands of passengers and their baggage. In the early 1900s, the railroads helped to boost tourism by running $1 excursions between Philadelphia and the Holly Beach, Wildwood, and Anglesea stations. (Union News Company, *c.* 1912.)

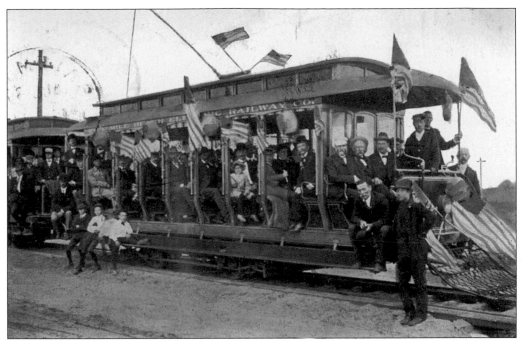

AN EXCURSION AT WILDWOOD. Riders paid only a nominal fare to ride this open-air trolley through the heart of the Wildwoods. The trolley line ran from Anglesea to Rio Grande Avenue. Opening on June 9, 1903, and in operation until 1946, these trolleys provided transportation for residents and vacationers alike. (Illustrated Postal Card Company, c. 1905.)

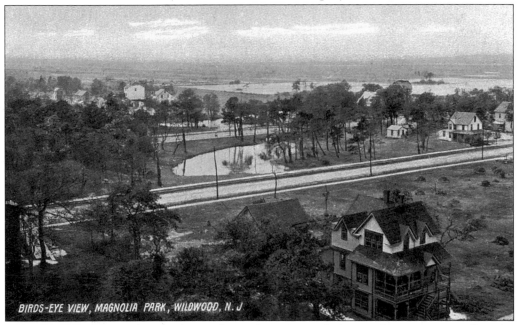

A BIRD'S-EYE VIEW. This aerial view shows the vicinity of what was known as Magnolia Lake. The lake is in the center of this panoramic scene, while Grassy Sound is visible in the distance. It was the primeval forests and extensive vegetation in this area of Five Mile Beach that first attracted many of the early visitors to the Wildwoods. (R.W. Ryan, c. 1907.)

31

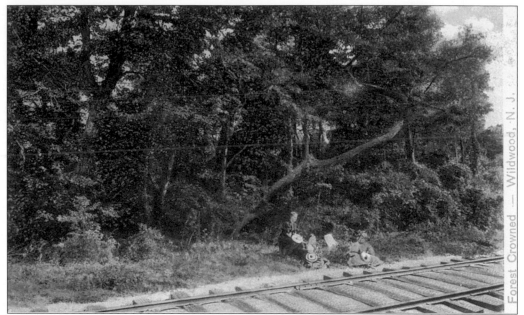

A Forest Crowned. Visible in this postcard view is some of the dense vegetation and mature tree growth typical of some parts of the very early Wildwoods. This scenic woodland and its rich variety of flora were originally proclaimed by the early promoters as reason to come visit this island resort. (Wildwood Post Card Company, *c.* 1907.)

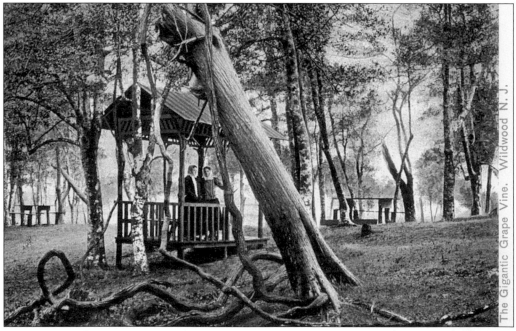

A Gigantic Grapevine. In an area sometimes called Magnolia Park, some of the dense flora and mature vegetation was allowed to survive for a number of years. This gigantic, wild grapevine was only one of the botanical wonders to behold. Behind the vine is a small gazebo–like structure where visitors could sit and enjoy the natural beauty of the surroundings. (Wildwood Post Card Company, *c.* 1906.)

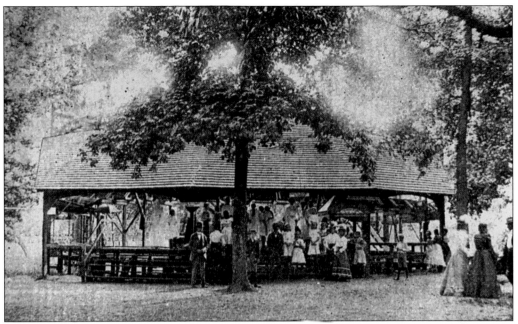

A TOBOGGAN SLIDE. In a woodland setting, possibly Magnolia Park, this wooden toboggan slide was one of the earliest amusement-style rides in the Wildwoods. This simple thrill machine helped to delight excursionists who came to the resort at the turn of the century. (Publisher unknown, *c.* 1906.)

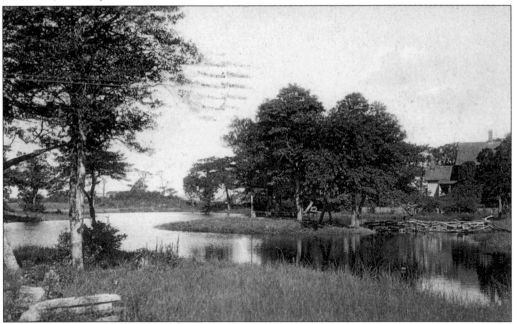

MAGNOLIA LAKE. Magnolia Lake, which was located where Wildwood and New Jersey Avenues now meet, was a very popular recreational area during the early days of the Wildwoods. People came to enjoy the natural beauty and serenity of the location. The lake's water even served as a source for ice, which, harvested in the winter, was stored for use during the summer months. (R. W. Ryan, *c.* 1908.)

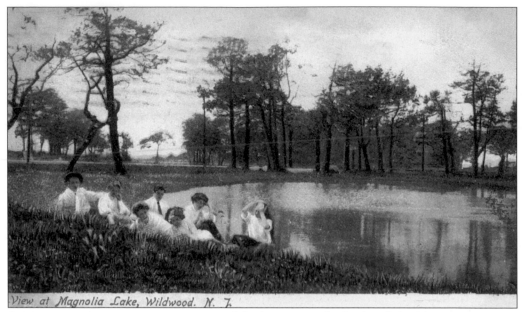

View at Magnolia Lake, Wildwood. N. J.

A VIEW OF MAGNOLIA LAKE. Young adults lounge on the banks of the lake, enjoying each other's company and the tranquility of the area. Surrounded by mature tree growth, the lake was a favorite picnic spot for many visitors to Wildwood. Sadly, such simple pleasures would end when the lake was drained to allow for more land development as the resort grew. (Illustrated Postal Card Company, *c.* 1906.)

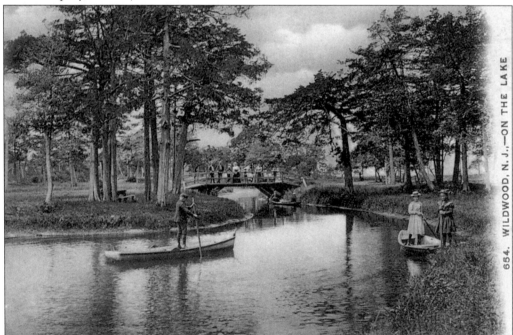

654. WILDWOOD, N. J.,—ON THE LAKE

ON THE LAKE. Boating was one of the more popular lake activities. Canoeing or poling a boat across the shallow, still waters of the lake could be a relaxing way to spend an afternoon. In reality, this body of water consisted of two small lakes, Magnolia and Cedar Lakes. The two areas of water were separated by the small bridge seen here. (Publisher unknown, *c.* 1906.)

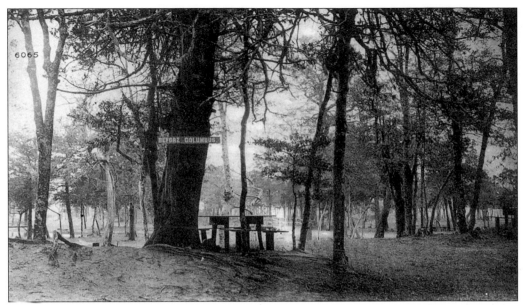

BEFORE COLUMBUS. Early in its history, the Wildwoods were home to massive oak, cedar, and holly trees. It was this thick vegetative growth that gave Wildwood its name. This view shows what was called the Columbus Tree. The tree was said to be more than 500 years old, dating back to the time before Columbus sailed to America. (Wildwood Post Card Company, *c.* 1905.)

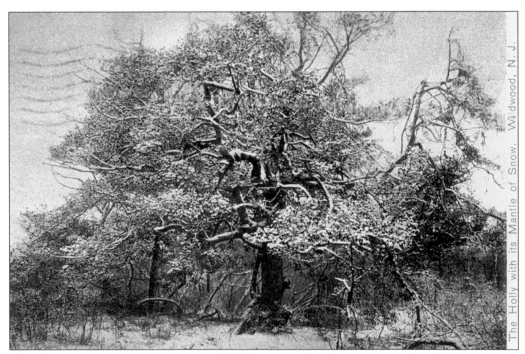

HOLLY WITH A MANTLE OF SNOW. Tall holly trees such as this one, covered with a winter snow, were once a common sight on the island. It was the presence of this type of vegetation that gave Holly Beach its name. Early in the history of the area, this holly was harvested commercially for use in Christmas decorations. (Wildwood Post Card Company, *c.* 1909.)

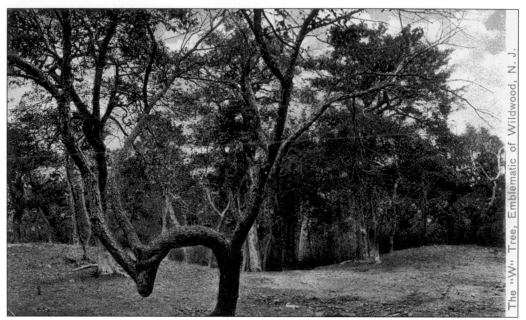

THE W TREE. Growing in the forest where Pine and Wildwood Avenues are now located was the W Tree. The unique twisted shape of this holly tree was to become a symbol of Wildwood. In 1890, Pres. Benjamin Harrison, while visiting the area, asked to have his picture taken with the tree. A section of this tree is now on display in the Wildwood Historical Museum. (Wildwood Post Card Company, *c.* 1908.)

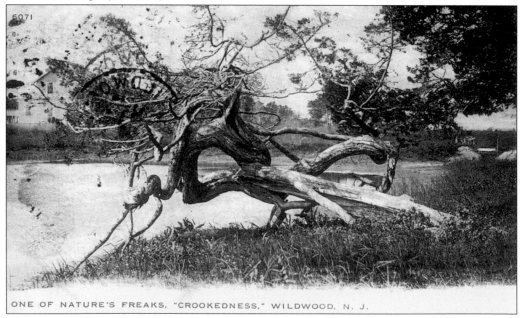

ONE OF NATURE'S FREAKS. "CROOKEDNESS," WILDWOOD, N. J.

ONE OF NATURE'S FREAKS. This unusual growth is another example of the twisted and bizarre types of vegetation that could be found on the island. The branches of these trees would be collected by locals, who would fashion souvenirs from them during the winter. These unique mementos would then be sold to the tourists who came during the summer months. (Wildwood Post Card Company, *c.* 1906.)

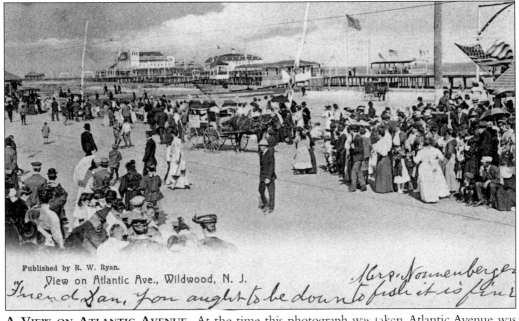

View on Atlantic Ave., Wildwood, N. J.

Mrs. Nonnenberger
Friend Jan, you aught to be down to fish it is fine

A VIEW ON ATLANTIC AVENUE. At the time this photograph was taken, Atlantic Avenue was the closest street to the ocean, and it bustled with activity. As the beach expanded eastward over the years, it was necessary to construct a new thoroughfare, which came to be named Ocean Avenue. This left Atlantic Avenue one block inland from the beach and boardwalk. (R.W. Ryan, *c.* 1906.)

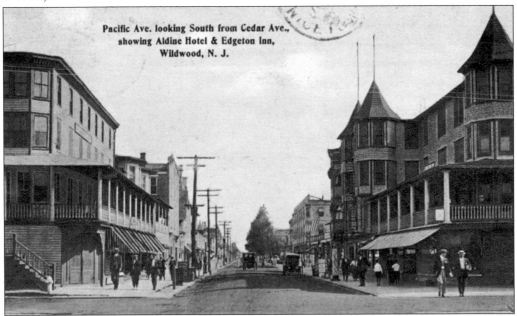

Pacific Ave. looking South from Cedar Ave.,
showing Aldine Hotel & Edgeton Inn,
Wildwood, N. J.

PACIFIC AVENUE, LOOKING SOUTH. Running north and south just one block west of Atlantic Avenue, Pacific Avenue was one of the more commercial thoroughfares in Wildwood and Holly Beach. The street was a prime downtown area with shops and markets that offered a variety of goods and services. In this view, the Aldine Hotel and Edgeton Inn are seen on opposite corners of Cedar Avenue. (Post Card Distribution Company, *c.* 1913.)

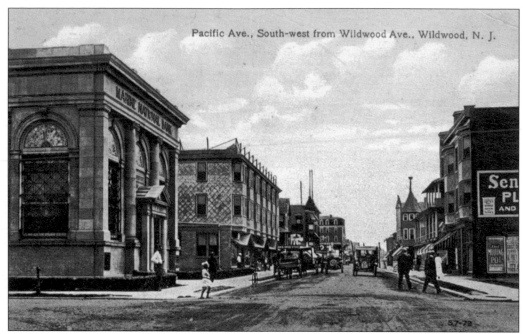

PACIFIC AVENUE. Looking down Pacific Avenue from Wildwood Avenue, this view shows some of the commercial development that existed during the early 1900s. On the corner is the Marine National Bank, while down the street are seen the Poplars Hotel, Edgeton Inn, Colony Hotel, and the Seacrest. (R.W. Ryan, *c.* 1914.)

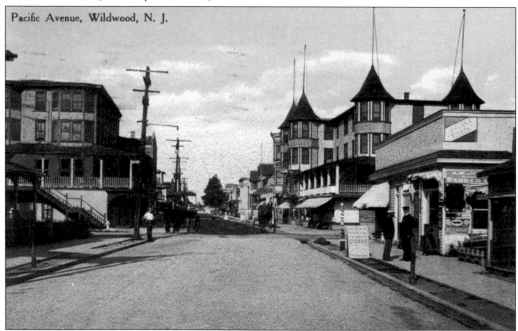

Pacific Avenue, Wildwood, N. J.

PACIFIC AVENUE. This is another view of Pacific Avenue with the Hotel Aldine and Edgeton Inn on the corner. A striped barber pole at the curb indicates the presence of a barbershop, while the sign board advertises the tobacco shop on the right side of the picture. (George E. Mousley, *c.* 1910.)

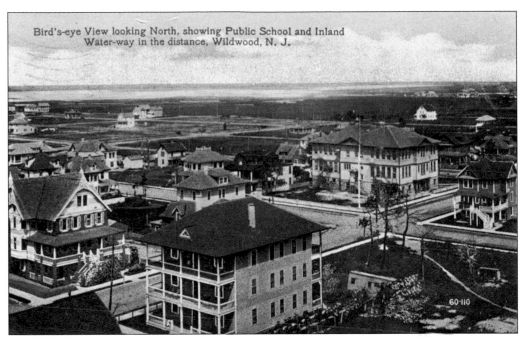

Bird's-eye View looking North, showing Public School and Inland Water-way in the distance, Wildwood, N. J.

60-110

A BIRD'S-EYE VIEW. This view looks out to the north of the city. The vista shows that quite a bit of empty and undeveloped land still existed in 1912, when the picture was taken. These sites would eventually be used for new homes, hotels, and other construction as the city grew. A notable building seen here is the three-story public school with a flagpole in front. (R.W. Ryan, 1912.)

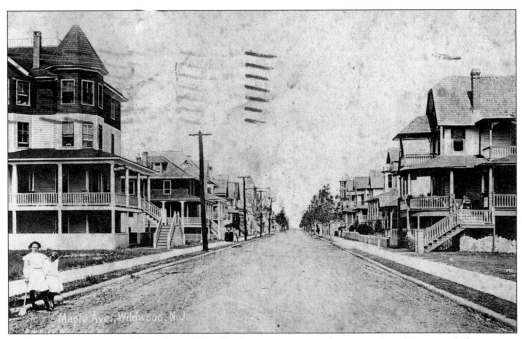

Maple Ave, Wildwood, N. J.

MAPLE AVENUE. Looking down Maple Avenue, we see the attractive three- and four-story homes and rooming houses that were typical of the era. This avenue was not as commercialized as some of the other streets and had more of a residential atmosphere. (R.W. Ryan, *c.* 1907.)

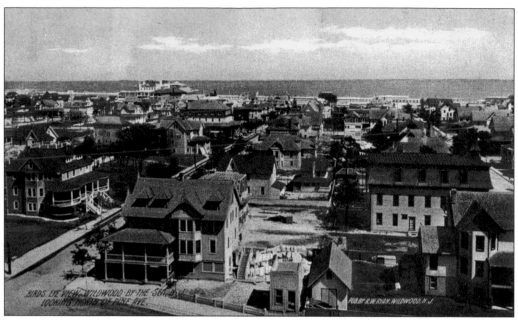

A Bird's-Eye View. Postcards offering a bird's-eye view were popular during the early 1900s. This particular view is looking north of Pine Avenue, with the ocean off in the distance. The population of Wildwood was to grow to 3,858 year-round residents by 1915. Just like today, however, this population would soar as vacationers arrived during the summer months. (R.W. Ryan, *c.* 1910.)

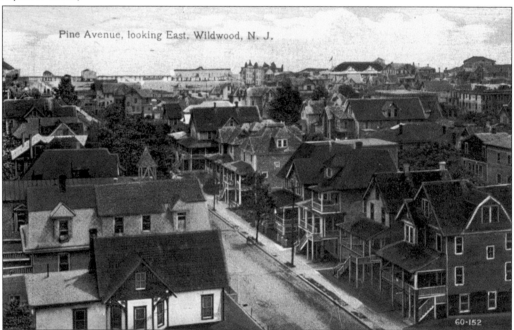

Pine Avenue. Looking east down Pine Avenue, this view shows the boardwalk and the Casino off in the distance. This particular block of Pine Avenue is a residential-type neighborhood, consisting of homes and, perhaps, some rooming houses. Postcard views such as this give us a feel for what the streets of Wildwood once looked like. (R.W. Ryan, 1912.)

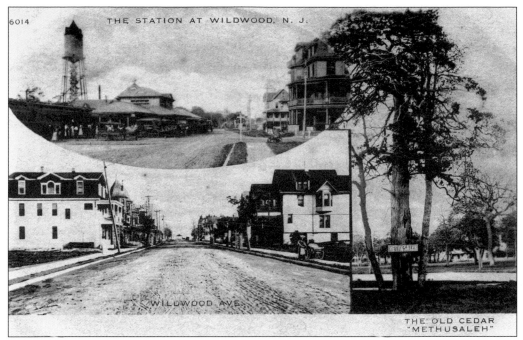

MULTIPLE WILDWOOD AVENUE VIEWS. The three photographic views on this postcard were all found in the vicinity of Wildwood and New Jersey Avenues. A street scene of Wildwood Avenue and the nearby railroad station are depicted, as is the old cedar tree named Methuselah. This ancient tree, noted for its great age, still stands at Wildwood and New Jersey Avenues. (Wildwood Post Card Company, *c.* 1906.)

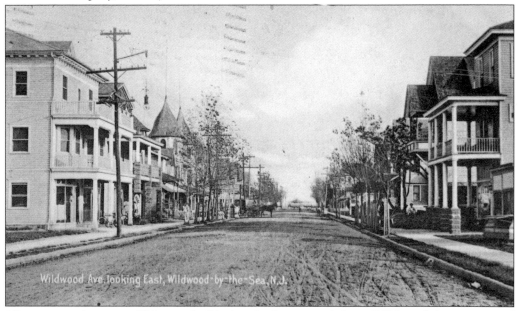

WILDWOOD AVENUE. This wonderful view looks eastward down Wildwood Avenue toward the ocean in the far distance. Even though the street is unpaved, there are streetlights suspended from the telephone poles. The streets seem wide, but this perspective changed when automobiles became commonplace and parking spaces much sought after. (R.W. Ryan, *c.* 1908.)

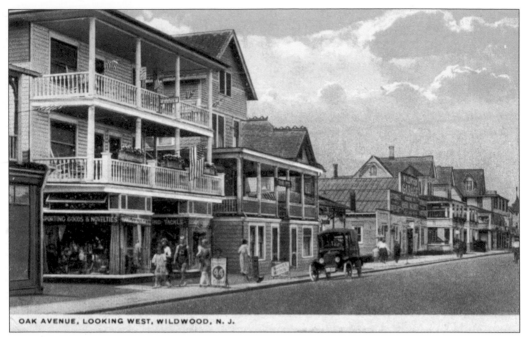

OAK AVENUE, LOOKING WEST, WILDWOOD, N. J.

ALONG OAK AVENUE. This postcard gives us a glimpse looking west along Oak Avenue. People are seen walking past a small sporting goods and novelties store. Above the store are furnished rooms offered for rent. Next door, the Ivy rooming house provides accommodations for vacationers. (John C. Funck, *c.* 1920.)

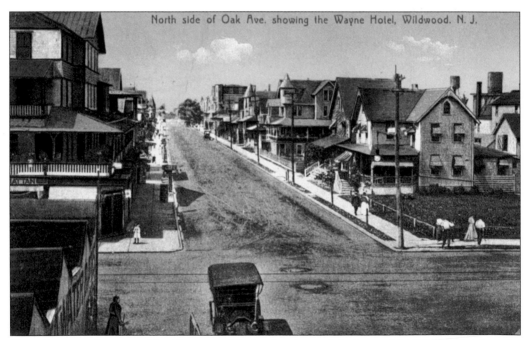

North side of Oak Ave. showing the Wayne Hotel, Wildwood. N. J.

OAK AVENUE. A young girl with a parasol in her hands stands in front of the Wayne Hotel on the corner of Oak Avenue. Visible are the trolley tracks that ran down the center of Atlantic Avenue. The properties along this street were well developed when this picture was taken. (R.W. Ryan, 1911.)

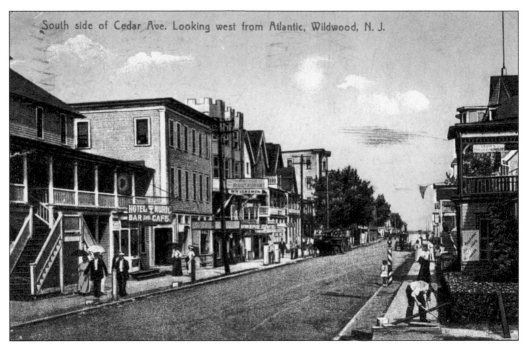

CEDAR AVENUE. Even before the street was paved, Cedar Avenue was a busy thoroughfare. On the south side of the street stands the Hotel Ruric with its bar and cafe, while down the block, several other cafes and restaurants are in business. Across the street from the Ruric is a barbershop. Unlike today, Cedar Avenue in the early 1900s extended all the way to New Jersey Avenue. (R. W. Ryan, 1911.)

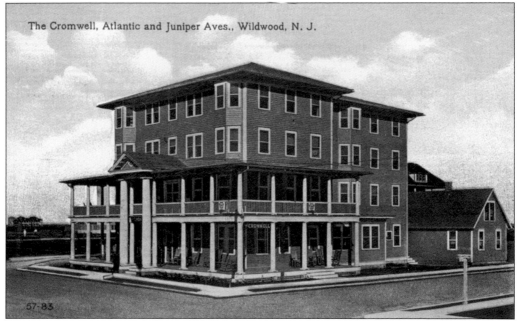

THE CROMWELL. Situated on the corner of Juniper and Atlantic Avenues, this hotel contained 52 rooms with a listed capacity of 150 guests. The hotel met its fate in 1973, when a fire destroyed the building. (R. W. Ryan, c. 1914.)

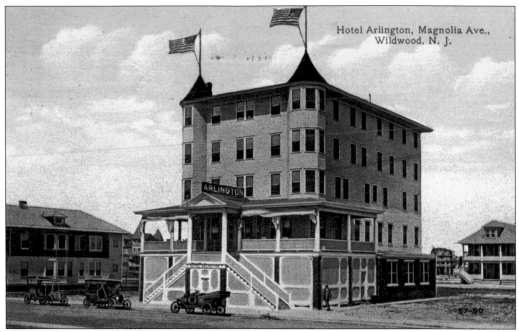

THE HOTEL ARLINGTON. This fine hotel was built by A.R. and C.H. Topham on Magnolia and Ocean Avenues. It first opened for business on Memorial Day weekend in 1913. A special feature of this building, also found on others of the era, was the second-floor entrance. (R.W. Ryan, *c.* 1914.)

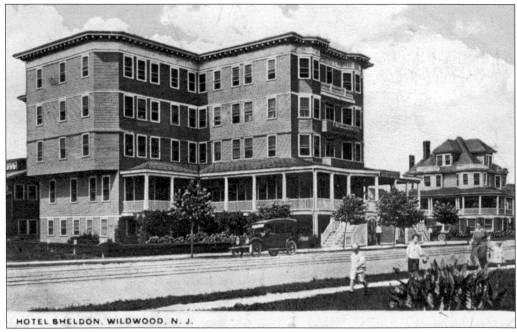

THE HOTEL SHELDON. This hotel, found at Magnolia and Atlantic Avenues, was typically open from May 25 to October 1. Under ownership of D.J. Woods, the hotel bragged of having an elevator capable of transporting guests to every floor, a fine dining room, and large airy rooms. (A. Wilson, *c.* 1919.)

44

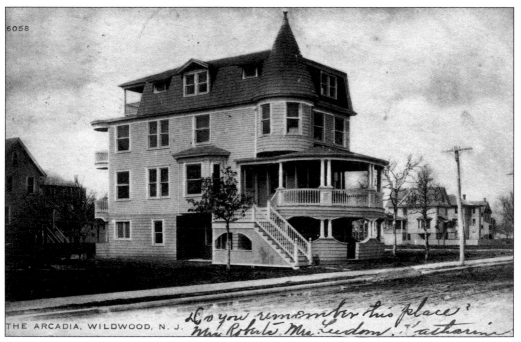

6058

THE ARCADIA, WILDWOOD, N. J.

Do you remember this place?
Mrs. Roberts. Mrs. Leedom. Catharine

THE ARCADIA HOTEL. Advertising itself as being only three quarters of a square from the ocean, the Arcadia Hotel stood at 206 Magnolia Avenue. It was described in a real estate brochure in 1908 as being "artistically and handsomely furnished throughout." (Wildwood Post Card Company, *c.* 1906.)

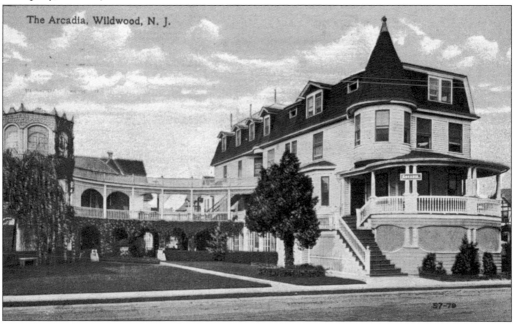

The Arcadia, Wildwood, N. J.

57-79

THE ARCADIA. In this *c.* 1914 view, it can be seen that the Arcadia underwent a number of changes over the years. It was extended in the rear and also connected to the adjoining property by a picturesque covered walkway. Unfortunately, this stately structure no longer exists, as it was torn down to make way for new development. (R.W. Ryan, *c.* 1914.)

45

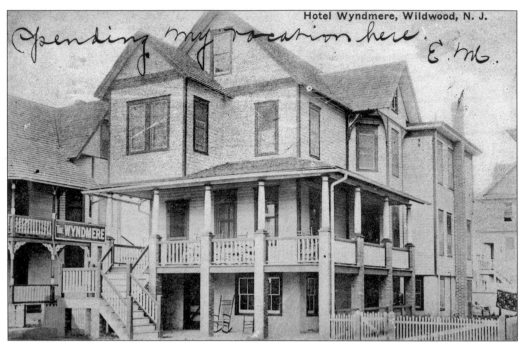

THE HOTEL WYNDMERE. The writer of this postcard sends the following message to his friend in Pottsville, Pennsylvania: "Spending my vacation here." The word *here* refers to the Hotel Wyndmere, a small but cozy lodging hall. Located at 229 Magnolia Avenue, it had a listed capacity of 50 people. (Philip Gould, *c.* 1911.)

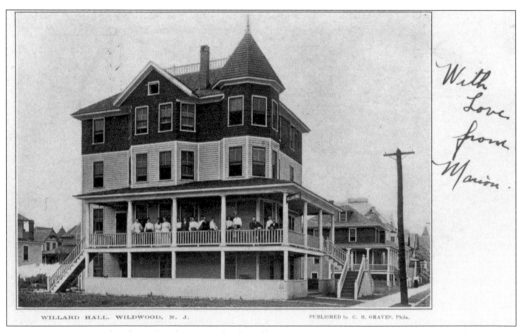

WILLARD HALL, WILDWOOD, N. J. PUBLISHED by C. H. GRAVES, Phila.

WILLARD HALL. This boardinghouse, which still stands today, was found at 228 Maple Avenue. In 1909, Sarah Wentzell was the proprietor. Later, it became the Bellavista (1929) and Maple Hall (1946). Since 1980, the building has been the Christian Society. (C. Graves, *c.* 1907.)

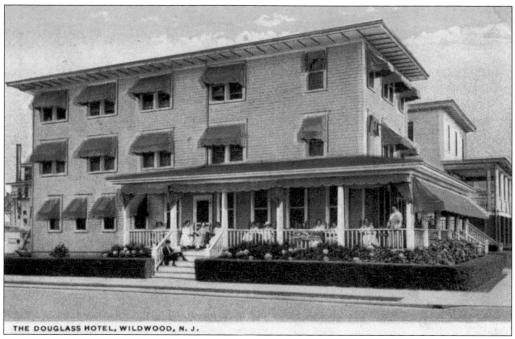

THE DOUGLASS HOTEL, WILDWOOD, N. J.

THE DOUGLASS HOTEL. The rocking chairs on the porch of the Douglass Hotel seem to be fully occupied in this postcard view. The canvas awnings on the windows and porch helped to keep things cool on hot summer days. Situated at Pine and Atlantic Avenues, the hotel could house up to 50 guests. (John C. Funck, c. 1920.)

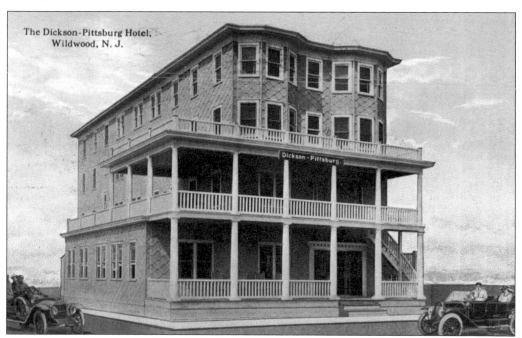

The Dickson-Pittsburg Hotel, Wildwood, N. J.

THE DICKSON-PITTSBURG HOTEL. Located at 336 Pine Avenue, this four-story hotel advertised that its guests would have an unobstructed view of the ocean. It also claimed to be within a mere two-minute walk of Wildwood's famous beach. (William H. Iszard, c. 1914.)

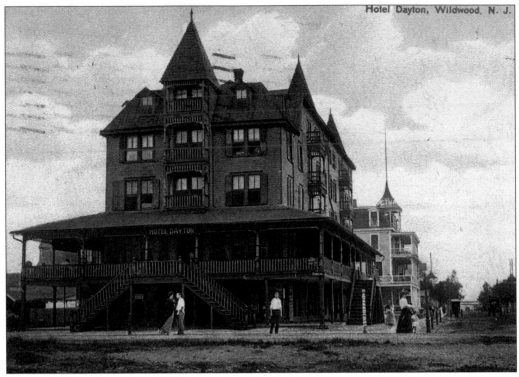

THE HOTEL DAYTON. Located at Wildwood and Atlantic Avenues, this hotel was dedicated in August 1890. Among the attendees at this momentous occasion was Pres. Benjamin Harrison. Considered one of the area's more upscale hotels, it could accommodate 250 guests. Notice the unpaved streets at the time of this photograph. (American News Company, *c.* 1910.)

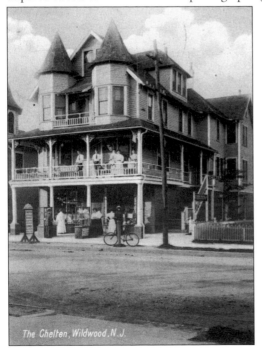

The Chelton, Wildwood, N.J.

THE CHELTON. On the east side of Wildwood Avenue stood the Hotel Chilton. While guests of the hotel stand on the second floor balcony, potential customers of the store beneath gaze at the window displays. A sign outside advertises summer goods and candy. (R.W. Ryan, *c.* 1908.)

48

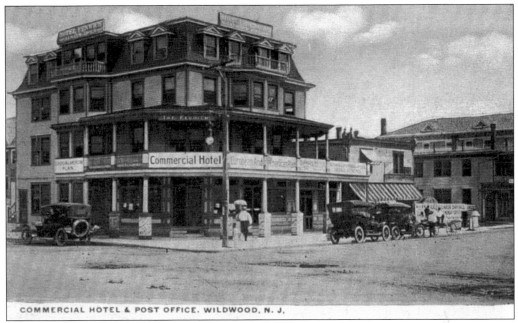

COMMERCIAL HOTEL & POST OFFICE. WILDWOOD, N. J.

THE COMMERCIAL HOTEL AND POST OFFICE. This building was home to the Fenwick Hotel, located on the corner of Wildwood and Holly Beach (later New Jersey) Avenue. Open all year, the hotel was managed by M.E. McGeorge. The first floor of the establishment, once occupied by the post office, is still standing. However, the upper floors of this historic building have been removed. (National Post Card Company, *c.* 1915.)

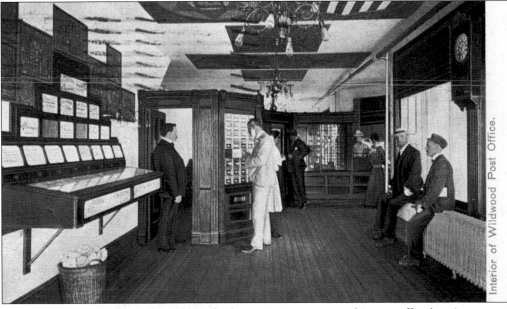

Interior of Wildwood Post Office.

THE POST OFFICE. A postal employee looks on as a patron opens his post office box in quest of mail. The interior of the post office possessed beautiful woodwork and an impressively decorated ceiling. The beautiful designs in the ceiling were created from canceled American and foreign postage stamps. Undoubtedly, many of the postcards used in this book passed through this facility. (Wildwood Post Card Company, *c.* 1910.)

49

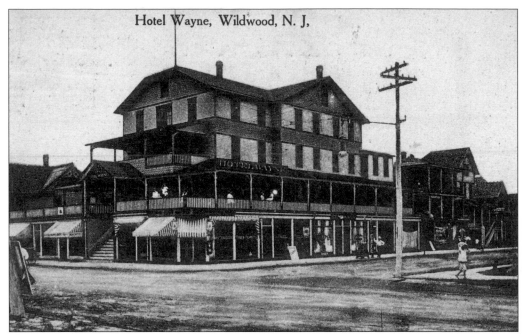

Hotel Wayne, Wildwood, N. J,

THE HOTEL WAYNE. At the corner of Oak and Atlantic Avenues, the Hotel Wayne was originally named the Marine Hotel. Opened to the public all year, the business was owned by Garrison and Cromwell Hurff at the time this photograph was taken. (Publisher unknown, *c.* 1912.)

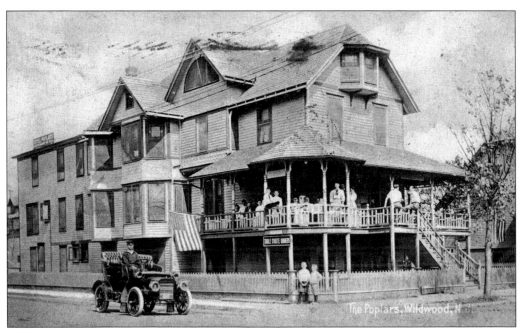

THE POPLARS. One of Wildwood's earlier hotels, the Poplars was built *c.* 1896 and sat on the corner of Oak and Pacific Avenues. For a number of years, there was a post office located on the first floor. A fire on September 9, 1919, ended the existence of this dignified building. (Rotograph Company, *c.* 1907.)

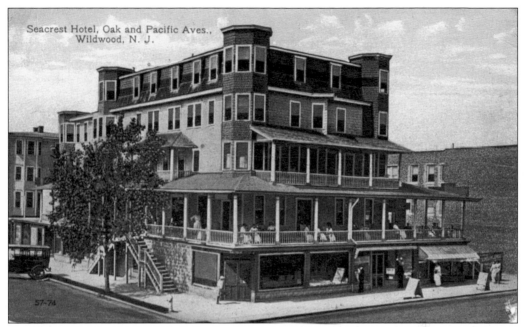

THE SEACREST. At the corner of Oak and Pacific Avenues, the Seacrest was built *c.* 1906 by the Banks family, who retained ownership of the property until 1944. In 1930, fire damaged the upper floors, which were never again used for lodging. The upper floors were removed in the 1960s, and the first floor was occupied by Dunn's Shoe Store until the building was torn down in the 1970s. (R.W. Ryan, *c.* 1914.)

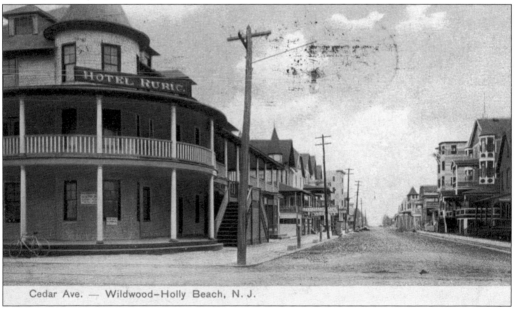

THE HOTEL RURIC. This hotel was built *c.* 1900 by Ruric Adams, who was a Wildwood borough councilman. Standing on the corner of Cedar and Atlantic Avenues, the Ruric was a landmark building that eventually became the Hotel Biltmore. After suffering fires in 1904 and 1928, it was finally consumed by flames in March 1960. (Wildwood Post Card Company, *c.* 1910.)

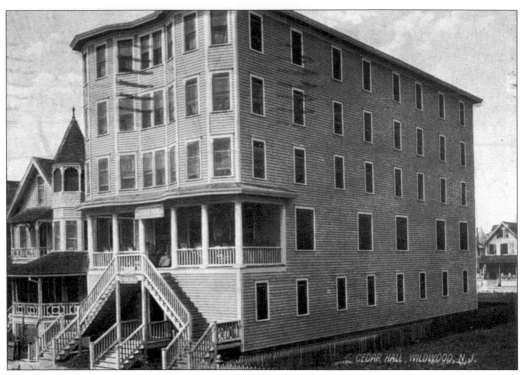

CEDAR HALL. This hotel and apartment building occupied a narrow lot on the east side of Cedar Avenue. Postcards such as this one helped to advertise the establishment and draw in new customers. (R.W. Ryan, *c.* 1907.)

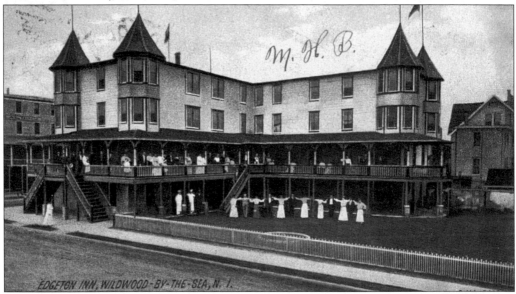

THE EDGETON INN. On the corner of Cedar and Pacific Avenues, the Edgeton Inn was one of Wildwood's better-known hotels at the turn of the century. With corner turrets and a second-story porch extending around three sides of the building, its architecture was quite distinctive. Centrally located near all the major attractions, the inn was reportedly popular with the young folks. (R.W. Ryan, *c.* 1907.)

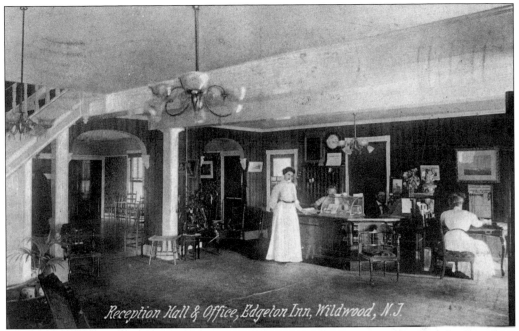

Reception Hall & Office, Edgeton Inn, Wildwood, N.J.

THE EDGETON INN RECEPTION HALL AND OFFICE. When visitors arrived to check in for a stay, they would be greeted by members of the staff in the reception and office area. By 1915, the hotel had 175 rooms and was equipped with every major appliance for the convenience and hygiene of its guests. (R.W. Ryan, c. 1908.)

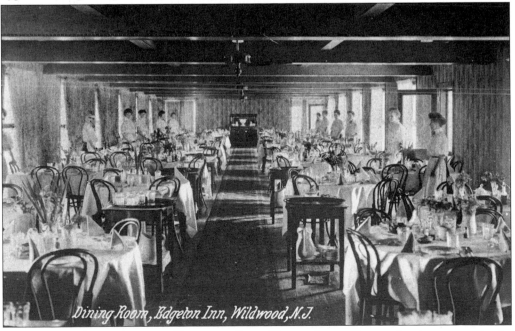

Dining Room, Edgeton Inn, Wildwood, N.J.

THE DINING ROOM OF THE EDGETON INN. The serving staff poses for the camera in the Edgeton Inn's formal dining room, which could seat 250. Here, elegantly set tables awaited guests of the hotel. Meals served in this stylish atmosphere helped make a stay here a memorable experience. (R.W. Ryan, c. 1908.)

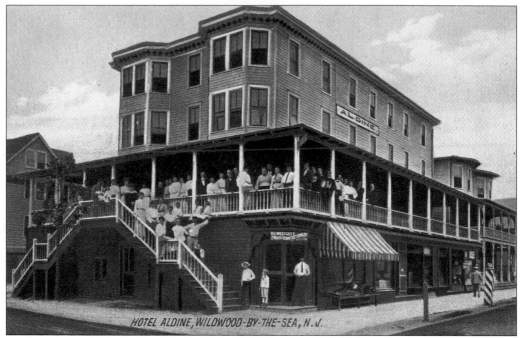

HOTEL ALDINE, WILDWOOD-BY-THE-SEA, N.J.

THE HOTEL ALDINE. On the northwest corner of Cedar and Pacific Avenues, and across the street from the Edgeton Inn, was the Hotel Aldine. At the time of this photograph, the first floor of the building was occupied by H.L. Westcott's Fruit and Confectionery Store. (Rotograph Company, c. 1907.)

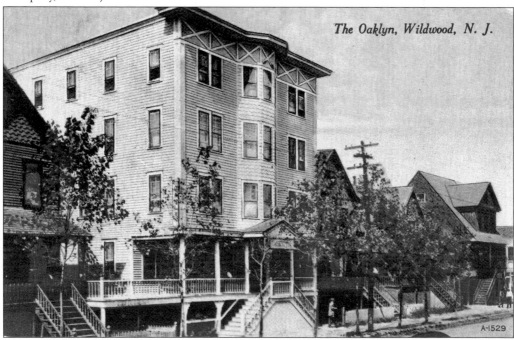

The Oaklyn, Wildwood, N. J.

THE OAKLYN. This hotel dates from the 1890s, when it provided mid-priced accommodations to its clientele. The hotel, which had a housing capacity of 130 people, was situated at 220 Cedar Avenue. (R.W. Ryan, c. 1910.)

54

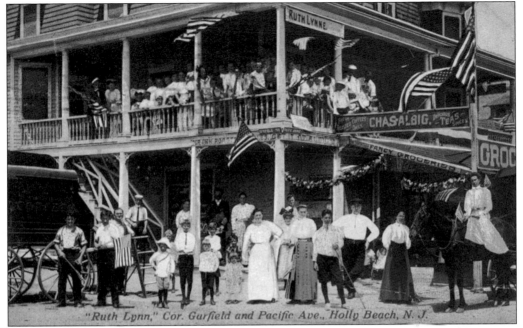

THE RUTH LYNNE. People gather at the porch rails and on the street as the photographer records this image of the Ruth Lynne Hotel. The hotel stood at the intersection of Garfield and Pacific Avenues. The first floor was occupied by Charles Alby's grocery store. In 1980, a fire, possibly arson, incinerated the building. (John Martin, c. 1910.)

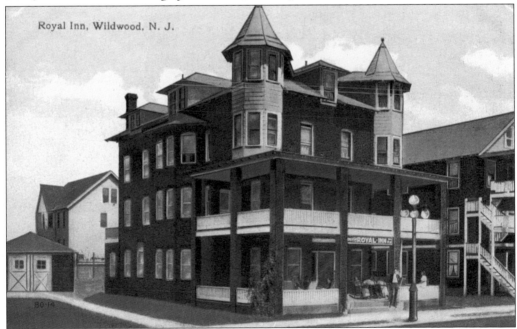

THE ROYAL INN. Constructed in 1910 on Young Avenue, this was one of the earliest hotels in Holly Beach. For a number of years, the inn was occupied during the winter months by the area's single teachers. (At the time, public school teachers were not permitted to marry.) The building is still in existence. (R.W. Ryan, c. 1914.)

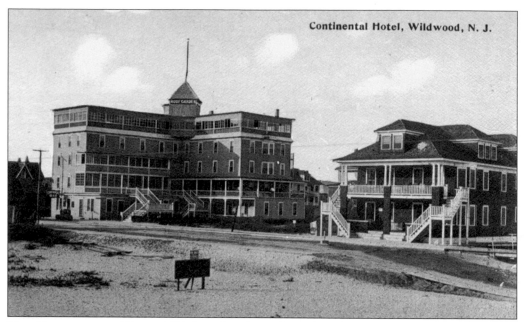

Continental Hotel, Wildwood, N. J.

THE CONTINENTAL HOTEL. This large hotel was situated on the east side of Baker Avenue. The Continental featured a first-floor bar and a rather unique roof garden. Unfortunately, the hotel had a relatively short life span, as it burned down on March 8, 1919. (Post Card Distribution Company, *c.* 1912.)

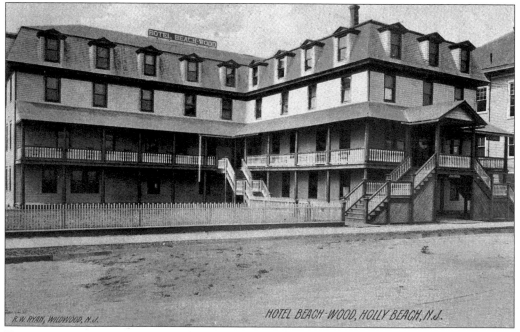

HOTEL BEACH-WOOD, HOLLY BEACH, N.J.

THE HOTEL BEACHWOOD. At the time of its opening in the summer of 1903, the Hotel Beachwood was the third-largest hotel on Five Mile Beach. It offered its patrons a choice of some 80 rooms and had a bowling alley on the premises. Located at 210 Montgomery Avenue, this establishment is still doing business today, although the bowling alley has been covered. (R.W. Ryan, *c.* 1907.)

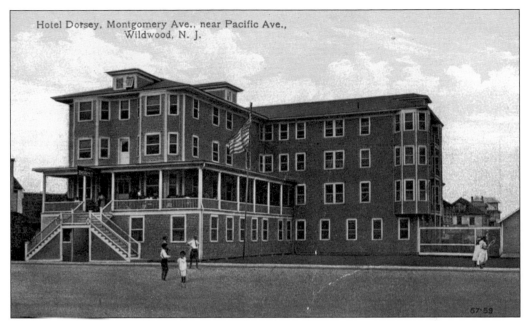

THE HOTEL DORSEY. Opened in June 1906, the Hotel Dorsey was built by James Whitesell, the borough clerk of Holly Beach. The hotel was owned and operated by the Whitesell family for many years. Located at Montgomery Avenue near Pacific Avenue, it stood across the street from the Hotel Beachwood. The Dorsey could accommodate 200 guests and offered private bath suites to its clients. (R.W. Ryan, *c.* 1914.)

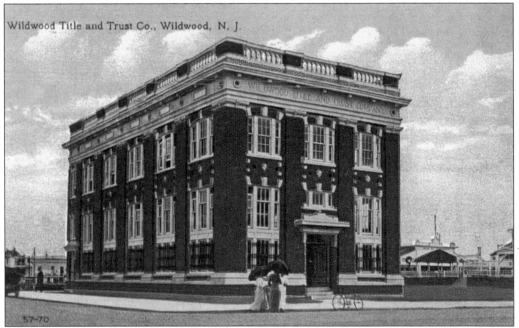

THE WILDWOOD TITLE AND TRUST COMPANY. Opening for business on August 9, 1913, with 85 stockholders, the Wildwood Title and Trust Company became an important financial institution in the area. No longer in operation, this commercial enterprise was located at Wildwood and Atlantic Avenues. (R.W. Ryan, *c.* 1914.)

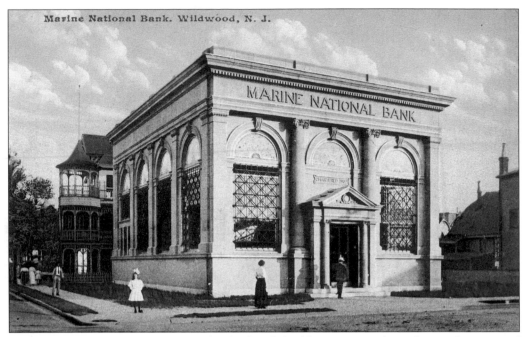

MARINE NATIONAL BANK

THE MARINE NATIONAL BANK. This landmark building is situated on the south corner of Wildwood and Pacific Avenues. Opened in the spring of 1908, the Marine National Bank was an important financial institution in the Wildwoods for many years. It became the home of the Crest Savings Bank on December 17, 1999. (R.W. Ryan, *c.* 1908.)

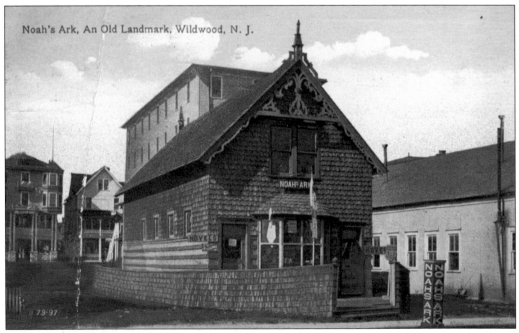

Noah's Ark, An Old Landmark, Wildwood, N. J.

NOAH'S ARK. A sign placed at the street curb identifies this interesting and rather unique landmark in Wildwood as the building called Noah's Ark. Found at 234 Oak Avenue, the property, with its boatlike shape, functioned as a book store owned by Thomas Connelly. (R.W. Ryan, 1914.)

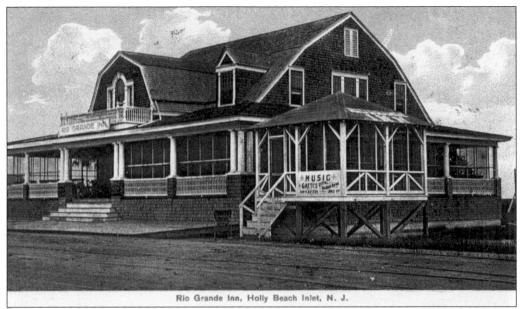

Rio Grande Inn, Holly Beach Inlet, N. J.

THE RIO GRANDE INN. The Rio Grande Inn, under the proprietorship of Hoffman and Baingo, was located at 515 Rio Grande Avenue. Located at the end of the trolley line, it was easily accessible to its patrons. A sign on the side of the building advertises an upcoming musical performance by Gotti's Royal Marine Band to be held on or around July 3. (American News Company, *c.* 1912.)

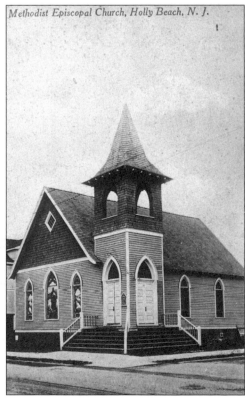

Methodist Episcopal Church, Holly Beach, N. J.

THE METHODIST–EPISCOPAL CHURCH.
This church, with its unusual double entrance, dates from 1909. Once inside the church, the worshipers could enjoy the large stained–glass windows in the front of this house of God. (Philip Gould, *c.* 1911.)

59

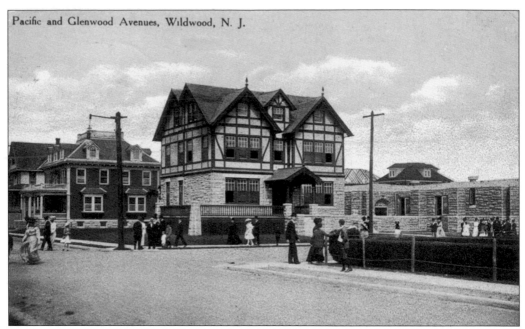

PACIFIC AND GLENWOOD AVENUES. On this corner of Glenwood and Pacific Avenues stands the English Tudor–style parish house of St. Ann's Catholic Church. The religious census of 1913 listed "235 white Catholics and three colored Catholics" in the parish. (George E. Mousley, *c.* 1910.)

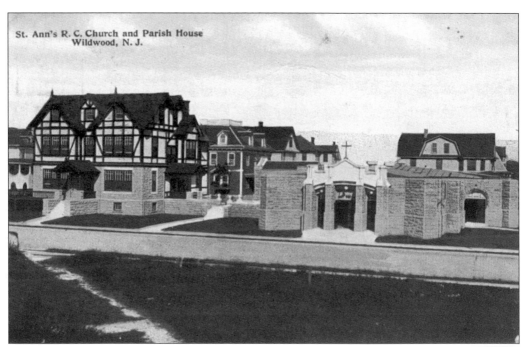

ST. ANN'S. Standing next to the parish house is the stone one-story St. Ann's. In 1926, a second story was added to the church to make room for the St. Ann's school. (R.W. Ryan, *c.* 1910.)

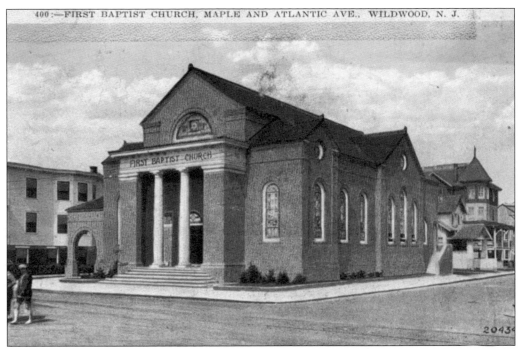

THE FIRST BAPTIST CHURCH. This Baptist church, found at Maple and Atlantic Avenues, was moved here from another location. A substantial brick building, it still exists and remains actively serving the religious needs of the local Baptist community. (Lynn H. Boyer, *c.* 1923.)

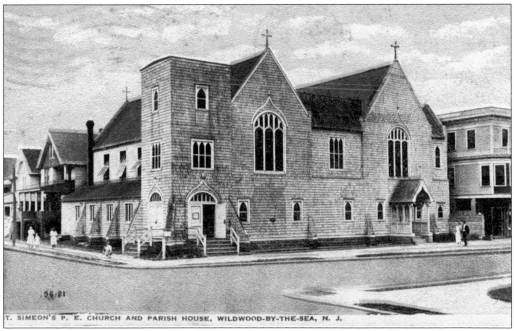

ST. SIMEON'S P. E. CHURCH AND PARISH HOUSE, WILDWOOD-BY-THE-SEA, N. J.

ST. SIMEON'S CHURCH. This Episcopal church was established by the St. Simeon's parish in Philadelphia, who awarded a contract in 1900 to build the church. The house of worship was erected on the corner of Maple and Pacific Avenues with the parish house adjoining it. (R.W. Ryan, *c.* 1914.)

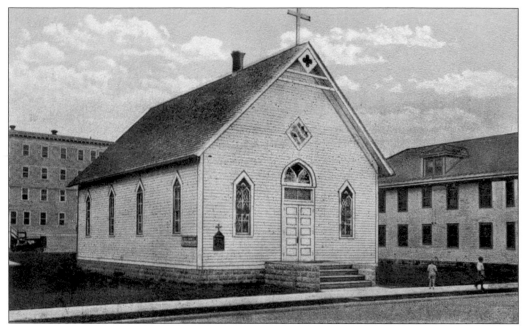

THE HOLY TRINITY LUTHERAN CHURCH. Officially organized on July 19, 1906, this modest-sized church, with its beautiful stained-glass windows, offered religious services to permanent residents and vacationers alike. Churches such as this have always played an important role in the life of the Wildwoods. (F.E. Funck, *c.* 1921.)

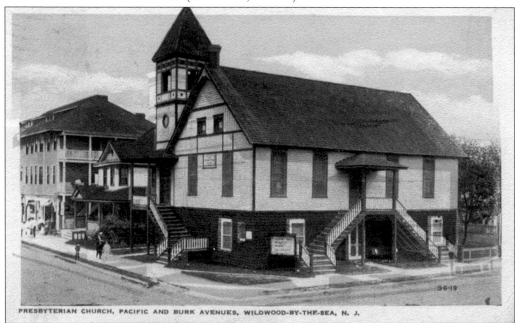

PRESBYTERIAN CHURCH, PACIFIC AND BURK AVENUES, WILDWOOD-BY-THE-SEA, N. J.

THE FIRST PRESBYTERIAN CHURCH. In 1885, an arson fire destroyed the original Presbyterian church. This wood-framed structure, which replaced it, served the congregation for more than 75 years until it was severely damaged by floodwaters during the Storm of 1962. The First Presbyterian Church still continues to exist at this site on Burk and Pacific Avenues. (R.W. Ryan, *c.* 1914.)

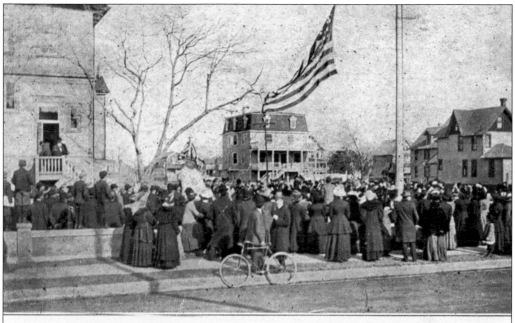

Flag Raising at Wildwood Public School, Lincoln's Birthday, February 12, 1909

THE GLENWOOD SCHOOL. The Glenwood Public School, on New York Avenue between Glenwood and Magnolia Avenues, was built on land donated by Philip Baker. About 30 students attended the school when it opened in 1902. Here, we see a flag-raising ceremony taking place at the school during a Lincoln's birthday celebration on February 12, 1909. (John C. Funck, 1909.)

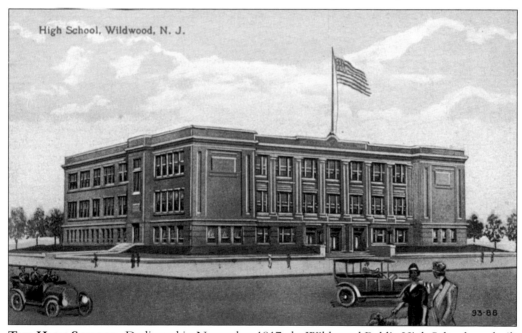

High School, Wildwood, N. J.

THE HIGH SCHOOL. Dedicated in November 1917, the Wildwood Public High School was built at Baker and Pacific Avenues. First expanded in 1927, it has undergone several other additions over the years. The school is still in operation on this site. (R.W. Ryan, c. 1919.)

63

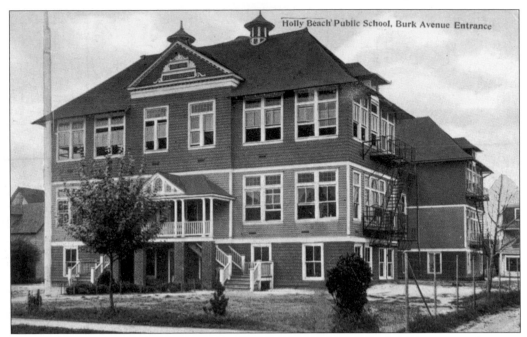

Holly Beach Public School, Burk Avenue Entrance

THE HOLLY BEACH SCHOOL. This public school in Holly Beach was located between New Jersey and Pacific Avenues. Some residents commonly referred to it as the Burk Avenue school, while to others, it was the Andrew's Avenue school. In 1903, 113 students attended this educational facility. Today, the site where the school stood is a park dedicated to fishermen. (R.W. Ryan, c. 1910.)

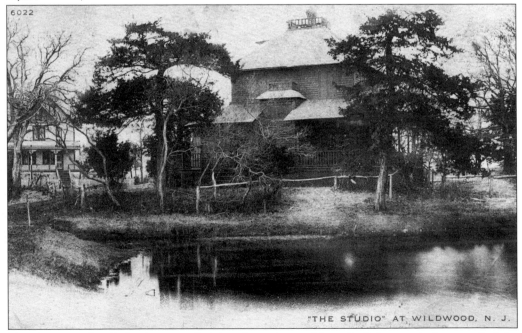

"THE STUDIO" AT WILDWOOD, N. J.

THE STUDIO. On Cedar Avenue, adjoining the park near Magnolia Lake, stood a house called the Studio. Situated where nature could be studied, it provided its owners a wonderful artistic view that overlooked the natural beauty of the area. (Wildwood Post Card Company, c. 1905.)

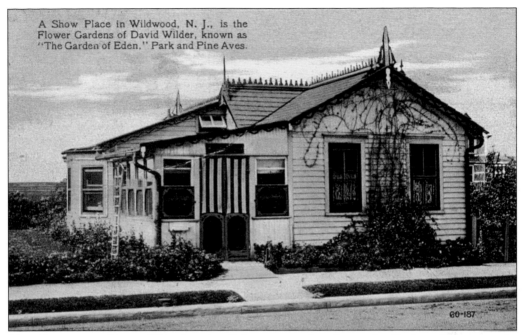

A Show Place in Wildwood, N. J., is the Flower Gardens of David Wilder, known as "The Garden of Eden," Park and Pine Aves.

60-187

THE GARDEN OF EDEN. This charming little cottage, referred to as the Garden of Eden, was the residence of David Wilder. Located at Pine and Park Avenues, it was for years known locally for its bountiful flower gardens. The dwelling was finally torn down in 2001. (R.W. Ryan, 1912.)

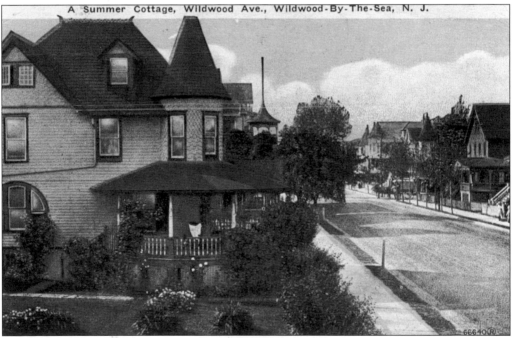

A Summer Cottage, Wildwood Ave., Wildwood-By-The-Sea, N. J.

66640®

A SUMMER COTTAGE. This house on Wildwood Avenue is typical of the architectural style of the times. It is hard to believe today that such substantial homes were referred to as cottages. Many of these served as summer residences for people who lived in the larger cities. (R.W. Ryan, c. 1922.)

65

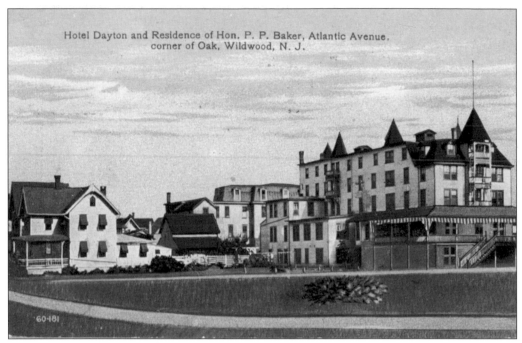

Hotel Dayton and Residence of Hon. P. P. Baker, Atlantic Avenue, corner of Oak, Wildwood, N. J.

60-181

THE RESIDENCE OF PHILIP PONTIUS BAKER. At the corner of Oak and Atlantic Avenues stood the home of Philip Pontius Baker. He and his two brothers were essentially the founders of Wildwood. In 1905, Baker purchased land south of Holly Beach and developed what was to become Wildwood Crest. On the right of the picture, the famous Hotel Dayton can be seen. (R.W. Ryan, 1912.)

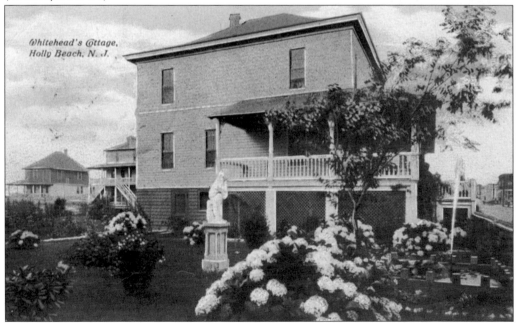

Whitehead's Cottage, Holly Beach, N. J.

THE WHITEHEAD COTTAGE. A beautiful garden, filled with blooms and even a water fountain, was within sight of pedestrians as they walked past this home at 223 Taylor Avenue. At the time this photograph was taken, it was the residence of the Whitehead family. (John Martin, *c.* 1910.)

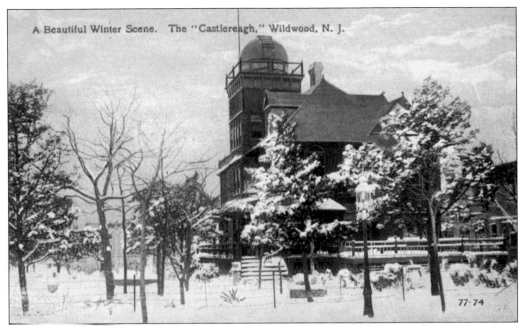

A Beautiful Winter Scene. The "Castlereagh," Wildwood, N. J.

77-74

THE CASTLEREAGH. This magnificent home at 130 Taylor Avenue was constructed for Clara Edgerton in 1885. Named the Castlereagh, it was purchased in 1904 by William H. Bright. This postcard view shows the residence after a snowstorm. (R. W. Ryan, *c.* 1914.)

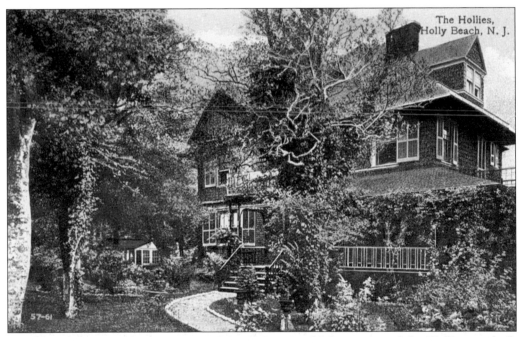

The Hollies, Holly Beach, N. J.

57-61

THE HOLLIES. Located at Leaming and Arctic Avenues, this home, named the Hollies, was built for Anne Starr in 1883. When her daughter Frances married actor and producer Carl A. Haswin, the house was renamed the Silver King. Children in the area often referred to the location as the "moose yard." The property had more than 20 varieties of trees on its grounds that were native to Five Mile Beach. (R. W. Ryan, *c.* 1914.)

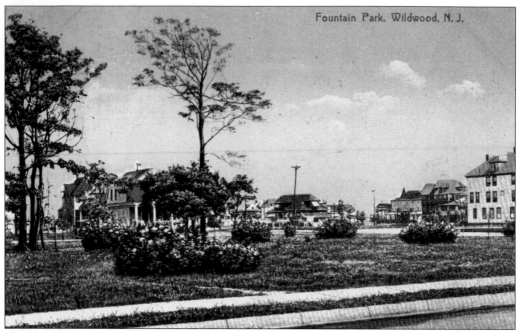

Fountain Park, Wildwood, N. J.

FOUNTAIN PARK. On New Jersey Avenue, between Glenwood and Magnolia Avenues, stands Fountain Park. A quiet little sanctuary for those wishing to pause and enjoy the beauty of its surroundings, the park still exists and provides visitors a place to stop and relax. (R. W. Ryan, 1911.)

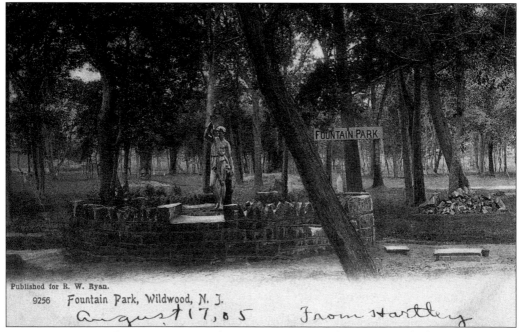

Published for R. W. Ryan.
9256 Fountain Park, Wildwood, N. J.
August 17, 05 From Hartley

INSIDE FOUNTAIN PARK. Set among the trees, Fountain Park provides a shady spot to sit and reflect. The small fountain and its statue add to the charm of the location. People standing in the park would hardly know that they are in the center of a bustling seaside resort. (R. W. Ryan, c. 1905.)

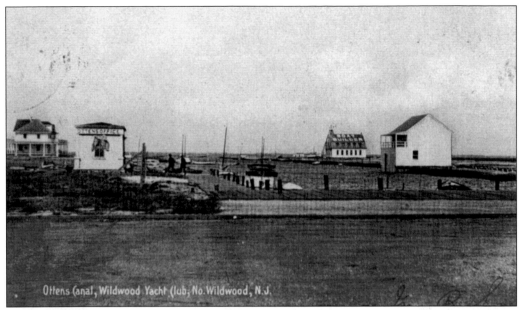

Ottens Canal, Wildwood Yacht Club, No. Wildwood, N.J.

AT OTTEN'S CANAL. Originally dug out by the Bakers, the canal was deepened and widened by Henry Ottens, who sold lots along the waterway for the building of cottages. Connected by trolley to other parts of the island, and a short walk from the railroad station, the site was easily accessible. On the left is the Wildwood Yacht Club, which was built in 1906 at a cost of more than $10,000. (R.W. Ryan, *c.* 1907.)

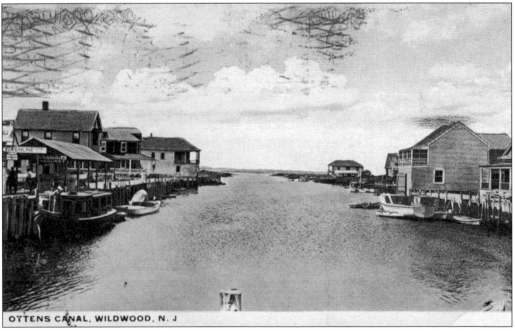

OTTENS CANAL, WILDWOOD, N. J

OTTEN'S CANAL. This photograph, taken *c.* 1918, shows that a number of cottages have been built along the bulkheaded canal on lots that originally sold for $100 to $400. On the left is a small business that furnished fuel for the boats motoring into this man-made lagoon. The mouth of the canal opens up to the Intercoastal Waterway. (A. Wilson, *c.* 1918.)

69

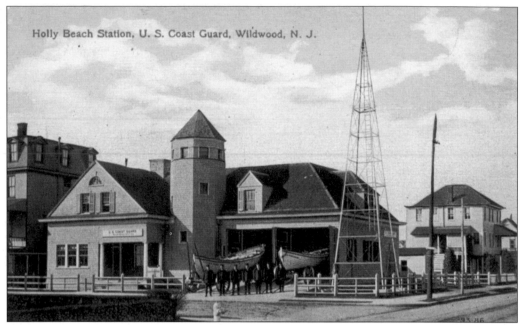

THE HOLLY BEACH COAST GUARD STATION. The Coast Guard took over this station when the U.S. Lifesaving Service ceased to exist. The facility, with its surf boats and crewmen, could be found at Leaming and Pacific Avenues. Today, the building is gone, but the work of the Coast Guard continues. (R.W. Ryan, c. 1914.)

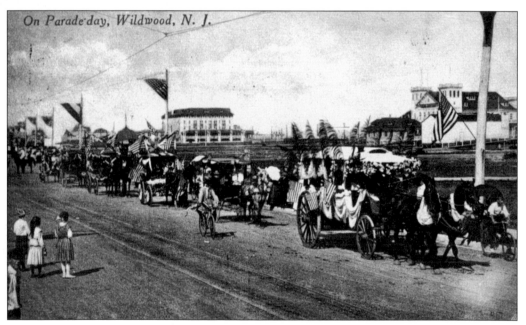

ON PARADE DAY. Memorial Day was the official beginning of the summer season. Parades were typically held to attract early visitors to the resort, as well as to celebrate the holiday. Here, a procession of horse-drawn wagons decorated with flags, flowers, and other embellishments proceeds down the avenue. (Philip Gould, c. 1911.)

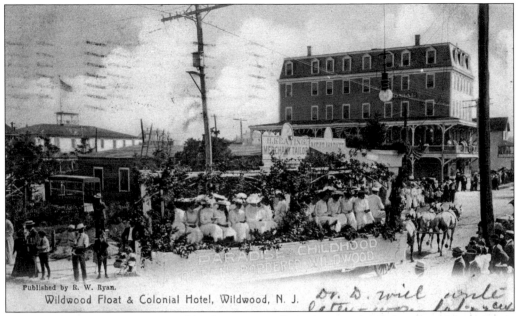

Wildwood Float & Colonial Hotel, Wildwood, N. J.

A WILDWOOD FLOAT. Crowds of spectators line the parade route as a horse-drawn, flower-bedecked float passes by. Riding on the float are more than two dozen young ladies similarly dressed in white gowns. The parade is proceeding toward the Colonial Hotel, on the corner of Schellenger and Pacific Avenues. (R.W. Ryan, *c.* 1906.)

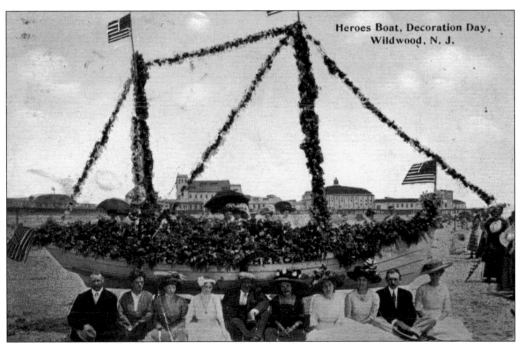

Heroes Boat, Decoration Day, Wildwood, N. J.

THE HEROES BOAT. As part of its Decoration Day (Memorial Day) festivities, Wildwood would honor America's naval heroes. Part of the ceremony was the launching of a boat decorated in flowers This postcard view shows a group of finely dressed individuals posing in front of the boat, which is resting on the beach. (John Martin, *c.* 1912.)

71

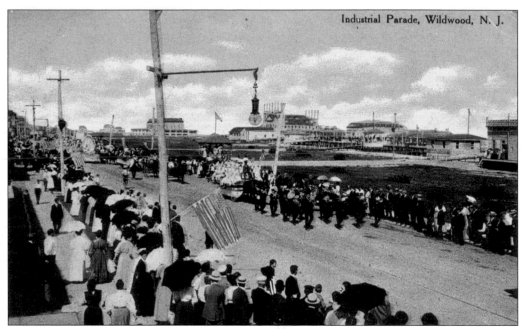

AN INDUSTRIAL PARADE. During the summer, different commercial organizations and manufacturers in and around Philadelphia would sponsor parades in Wildwood. The businesses would send their workers by train to participate in the parade and to enjoy a day at the shore. This parade is seen heading south along Atlantic Avenue. (George E. Mousley, *c.* 1910.)

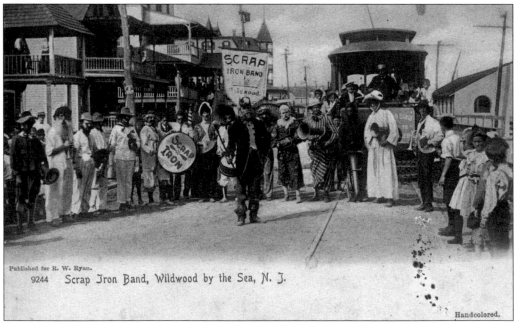

Published for R. W. Ryan.
9244 Scrap Iron Band, Wildwood by the Sea, N. J.

Handcolored.

THE SCRAP IRON BAND. On a seaside street in Wildwood, a musical group called the Scrap Iron Band stands waiting to perform for a group of onlookers. The band members, dressed in a motley assortment of comical costumes, marched in many parades, thus providing entertainment to summertime visitors. Prof. Harry Roselle of the Ocean Pier was their director. (R.W. Ryan, *c.* 1908.)

Three

WILDWOOD CREST

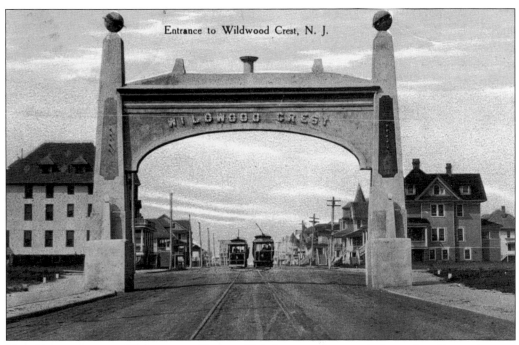

Entrance to Wildwood Crest, N. J.

THE ENTRANCE TO WILDWOOD CREST. This large concrete arch, located at Cresse Avenue, greeted visitors as they entered the borough of Wildwood Crest, just south of Wildwood. Trolleys such as those seen here connected the Wildwoods and provided transport between the resort areas. Wildwood Crest was developed on land purchased by Philip P. Baker in 1905 and was incorporated as a borough in 1910. (George E. Mousley, *c.* 1911.)

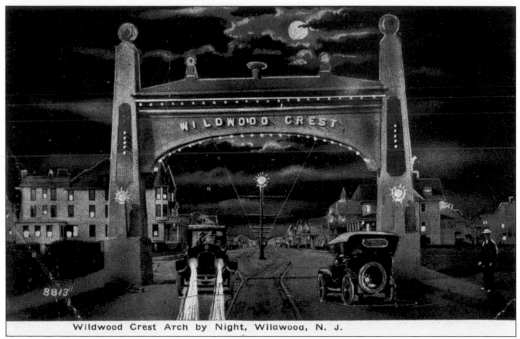

Wildwood Crest Arch by Night, Wildwood, N. J.

THE WILDWOOD CREST ARCH BY NIGHT. The large Roman-style arch was somewhat similar in design to the arch found at the entrance to North Wildwood. However, this one was illuminated at night by means of gaslights rather than electricity. This landmark structure was torn down sometime in the early 1920s, as weather eventually took its toll on the arch. (P. Sander, *c.* 1918.)

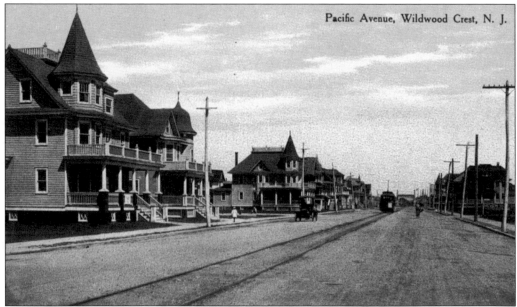

Pacific Avenue, Wildwood Crest, N. J.

PACIFIC AVENUE. Running through the heart of Wildwood Crest, this broad thoroughfare was lined with stately homes. A streetcar railway passes down the center of the avenue, while still providing ample room for automobile traffic on either side of the tracks. (George E. Mousley, *c.* 1912.)

74

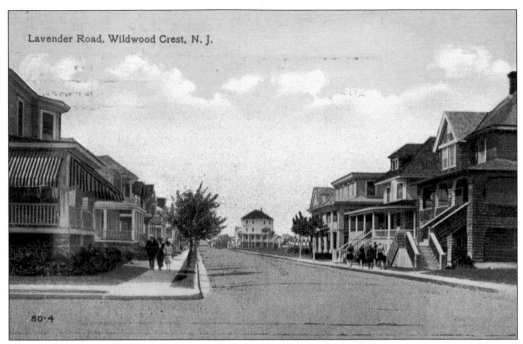

Lavender Road, Wildwood Crest, N. J.

80-4

LAVENDER ROAD. Three blocks south of Cresse Avenue, Lavender Road is a quiet residential area and is typical of the older streets in the Crest. Wildwood Crest did not have the same levels of commercial development as its sister communities to the north. (R.W. Ryan, *c.* 1914.)

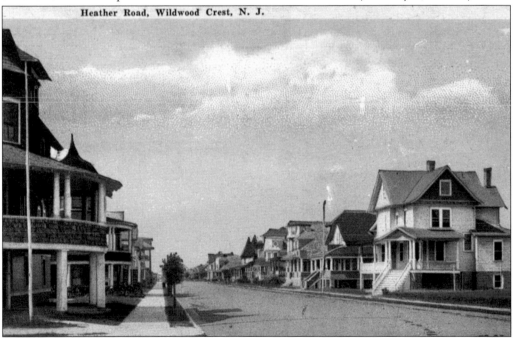

Heather Road, Wildwood Crest, N. J.

HEATHER ROAD. These large single homes are representative of the style of houses found in Wildwood Crest before 1925. While some of these were private residences, others were rented to summer vacationers who came to enjoy the pleasures and attractions of the Wildwoods. (R.W. Ryan, *c.* 1920.)

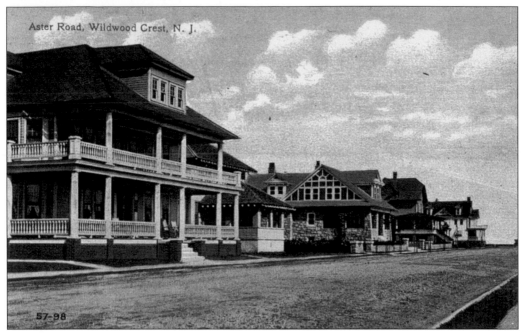

57-98

ASTER ROAD. Looking west down Aster Road, this view shows the Seaside Apartments on the left. Small rooming houses and apartments such as this offered guests quiet lodging in the years before motels and high-rise ocean-view hotels welcomed vacationers. (R.W. Ryan, *c.* 1914.)

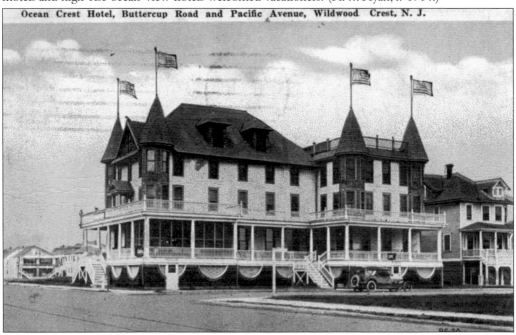

Ocean Crest Hotel, Buttercup Road and Pacific Avenue, Wildwood Crest, N. J.

THE OCEAN CREST HOTEL. Opening its doors in 1906, this grand hotel, on the corner of Pacific Avenue and Buttercup Road, was the first major hotel to be built in the Crest. At its inception, it had 50 rooms, each equipped with a telephone for the convenience of its guests. Many wealthy and prominent dignitaries reportedly stayed at this icon of Victorian style. The building was torn down in 2001. (R.W. Ryan, *c.* 1920.)

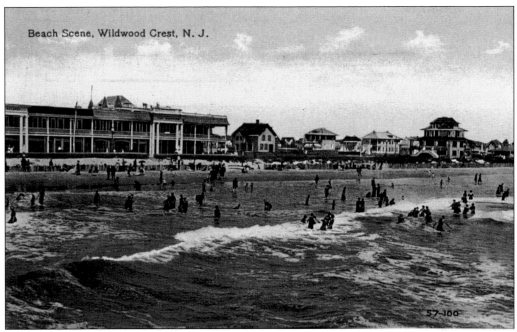

Beach Scene, Wildwood Crest, N. J.

57-100

THE SEWARD HOTEL. The Seward occupied the northern end of the building that it shared with the Atlanta Hotel. From this ocean vantage point, it can be seen just how close to the water's edge these hotels were situated. Located at 5600 Atlantic (now Seaview) Avenue, this former hotel has been converted into a condominium complex. (R. W. Ryan, *c.* 1914.)

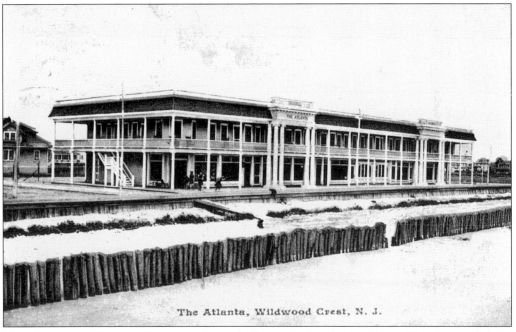

The Atlanta, Wildwood Crest, N. J.

THE ATLANTA HOTEL. Constructed practically on the beach, the Atlanta Hotel occupied the southern end of the same building as the Seward Hotel. A wooden seawall was built in front of the hotel to help protect it from any higher-than-normal ocean tides. Having been converted into condominiums, the structure still stands today. (R. W. Ryan, *c.* 1908.)

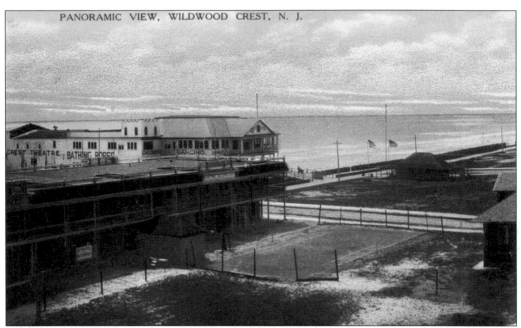

A PANORAMIC VIEW. A view from the landward side shows the southern end of the Atlanta Hotel with the Crest Pier behind it. Floodwaters from a storm in 1908 destroyed the Wildwood Crest Boardwalk and left the Crest Pier standing alone. Seaview Avenue was then created, and the Crest never again had a boardwalk of its own. (Publisher unknown, *c.* 1910.)

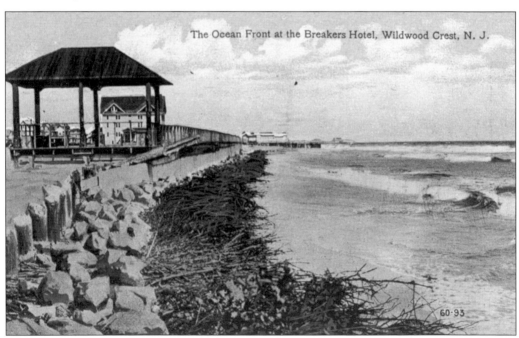

The Ocean Front at the Breakers Hotel, Wildwood Crest, N. J.

THE OCEANFRONT AT BREAKERS HOTEL. Ocean waves come up to the seawall by the pavilion in front of the Breakers Hotel. The hotel, which is not in view, was located at Orchid Road and the beach. Under the proprietorship of George K. Sinnamon, the hotel was open only from May 28 to October 1. (R.W. Ryan, 1912.)

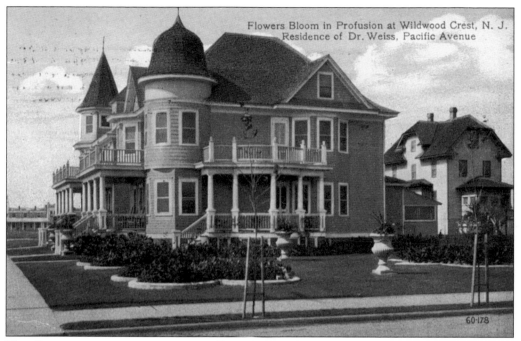

Flowers Bloom in Profusion at Wildwood Crest, N. J.
Residence of Dr. Weiss, Pacific Avenue

60-178

THE RESIDENCE OF A DR. WEISS. Still standing on the corner of Heather and Pacific Avenues is the former residence of a Dr. Weiss. Multitudes of flowers fill the flower beds that are precisely arranged on the well-manicured lawn of this beautiful home. (R.W. Ryan, 1912.)

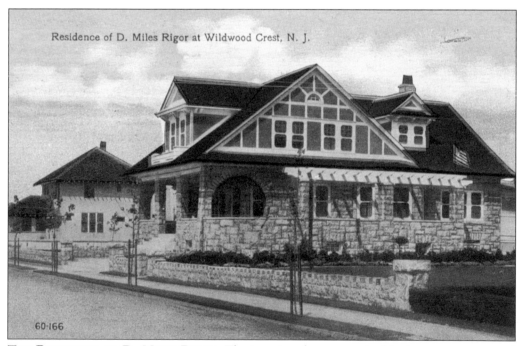

Residence of D. Miles Rigor at Wildwood Crest, N. J.

60-166

THE RESIDENCE OF D. MILES RIGOR. The two-story home seen in this view was once owned by D. Miles Rigor, owner of the Brighton Hotel in Wildwood. Rigor also operated a business that he referred to as a secret service (private detective) agency. (R.W. Ryan, 1912.)

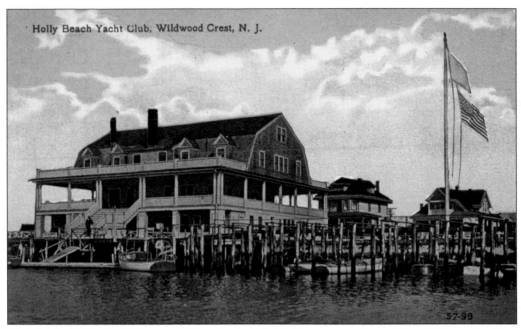

Holly Beach Yacht Club, Wildwood Crest, N. J.

57-99

THE HOLLY BEACH YACHT CLUB. Formed in 1904 to promote social activities and sailing pleasures for its members, the Holly Beach Yacht Club was to become an important institution in Wildwood Crest. In 1907, this large three-story clubhouse overlooking Sunset Lake was built by C.A. Norton. This photograph shows the building from the water and includes a view of the dock area. (R.W. Ryan, *c.* 1914.)

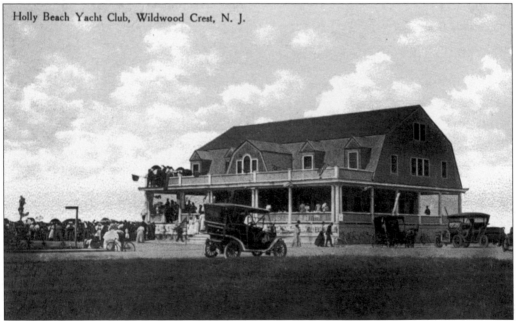

Holly Beach Yacht Club, Wildwood Crest, N. J.

A VIEW OF THE HOLLY BEACH YACHT CLUB. The clubhouse, situated at Park Boulevard and Sunset Lake, is seen here from the landward side. The attention of a large gathering of people seems to be drawn to the dock area behind and to the side of the building. Many events and activities would be held here over the years. (George E. Mousley, *c.* 1910.)

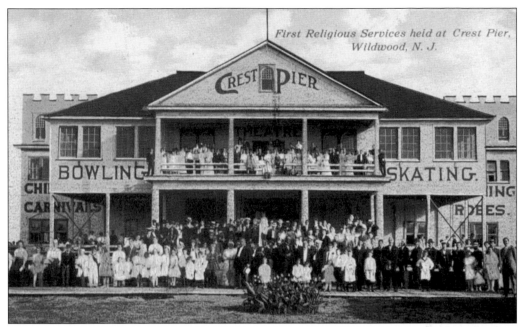

First Religious Services held at Crest Pier, Wildwood, N. J.

THE CREST PIER. Opened in 1906, the Crest Pier was the southernmost amusement pier in the Wildwoods. Destroyed by fire in 1917, it was rebuilt and, in May 1921, was reopened. In the 1940s, the entire structure was moved across Atlantic Avenue. This postcard shows a group portrait of those who attended the first religious service to be held at the pier. (John Martin, *c.* 1910.)

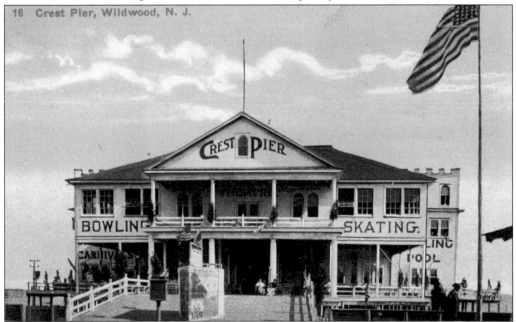

THE CREST AMUSEMENT PIER. The Crest Pier offered its patrons a wide assortment of diversions. Bowling, pool, dancing, a skating rink, and even fishing from the end of the pier was available. Motion pictures were shown here under the management of Billy Crozier, who was advertised as being Philadelphia's foremost baritone singer. A bathhouse also allowed visitors to enjoy the best beach in the area. (Publisher unknown, *c.* 1911.)

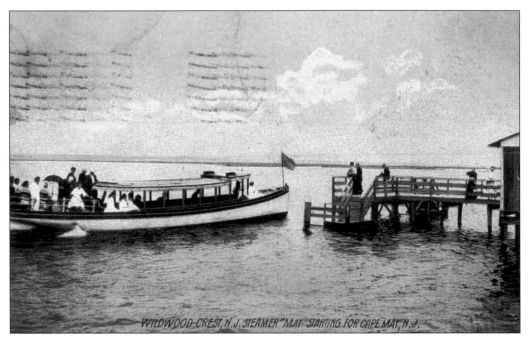

THE STEAMER *MAY* STARTING FOR CAPE MAY. During the early 1900s, the steam vessel *May* carried passengers between Wildwood Crest and its southern neighbor, Cape May. This form of transportation offered a pleasurable means of traveling between these two seaside resorts at a fare rate of 50¢ for adults and 30¢ for small children. (R.W. Ryan, *c.* 1908.)

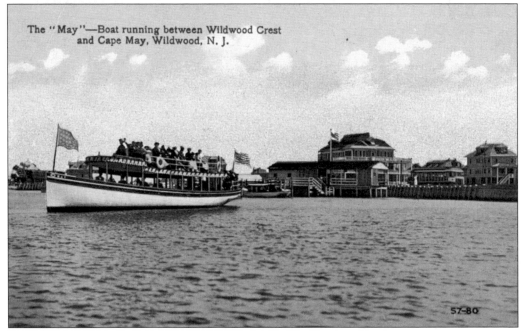

THE *MAY.* Here we see the steamer *May* after an upper deck had been added to accommodate more passengers. Located at the end of the trolley line, the dock site was very convenient for those wishing to travel to Cape May. In 1914, the vessel was owned by J. Albert Harris. (R.W. Ryan, *c.* 1914.)

Four

THE BOARDWALK

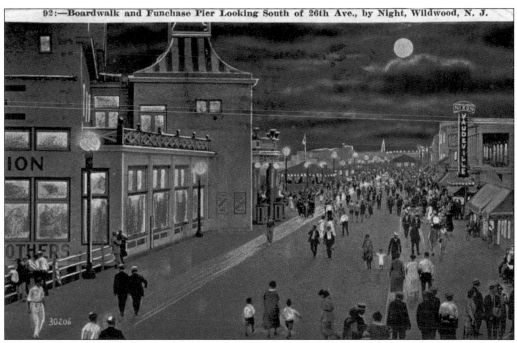

92:—Boardwalk and Funchase Pier Looking South of 26th Ave., by Night, Wildwood, N. J.

THE BOARDWALK SOUTH OF 26TH AVENUE. The boardwalk has long been the center of entertainment and amusement in the Wildwoods. Originally just a temporary wooden walkway on the sands along Atlantic Avenue, it became an elevated structure in 1903. Since then, it has seen several major renovations and rebuildings and has evolved into the two-and-a-half-mile-long world-famous promenade that it is today. (Lynn H. Boyer, *c.* 1925.)

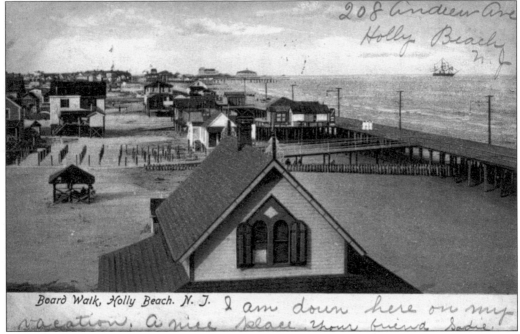

Board Walk, Holly Beach. N. J. I am down here on my vacation. A nice place your friend Sadie

208 Andrew Ave Holly Beach N. J.

THE HOLLY BEACH BOARDWALK. Officially opened on August 17, 1905, the Holly Beach Boardwalk stretched to a length of 4,925 feet and had a width of 32 feet. It connected to the Wildwood Boardwalk and ran south all the way to Cresse Avenue. In this view, the boardwalk looks rather vacant, but it was not long before this wooden promenade was lined with a variety of businesses. (Illustrated Postal Card Company, 1906.)

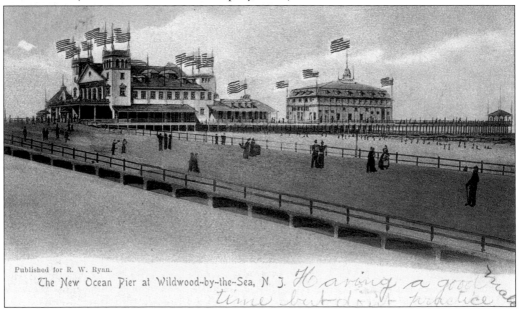

Published for R. W. Ryan.
The New Ocean Pier at Wildwood-by-the-Sea, N. J. Having a good time but don't practice

THE NEW OCEAN PIER. To expand the area available for entertainment, amusement piers were built extending far out into the ocean. The first in Wildwood was the Ocean Pier, located at Juniper and Poplar Avenues. The pier opened in 1905 and met its demise in a fire on Christmas Day 1943. (R.W. Ryan, *c.* 1906.)

84

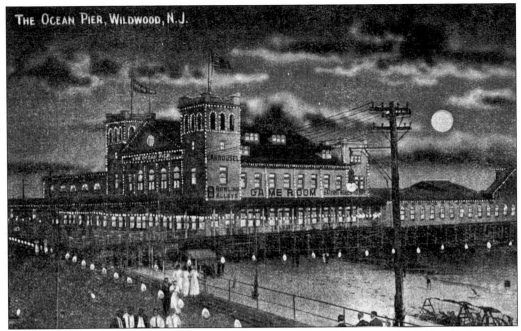

THE OCEAN PIER. This giant amusement pier was designed by architect Charles A. Brooke to accommodate up to 10,000 patrons at one time. With its two turrets standing 100 feet high and its roof of green, it was a very distinctive building. At night, the entire pier was illuminated by thousands of electric lights. (Postcard Distribution Company, *c.* 1913.)

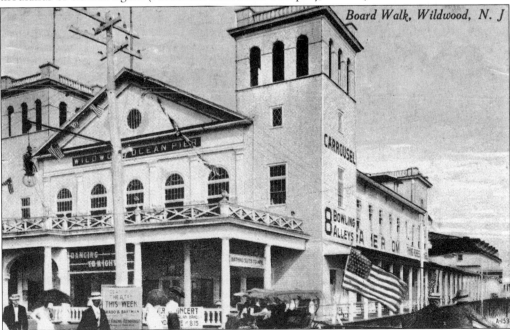

THE FAMOUS OCEAN PIER. The Wildwood Ocean Pier attracted huge numbers of patrons with its wide variety of amusements. A carousel, a performance theater, nighttime dancing, and even an eight-lane bowling alley afforded visitors a good time. A bathhouse also provided services for those wishing to spend the day on the beaches. (R. W. Ryan, *c.* 1911.)

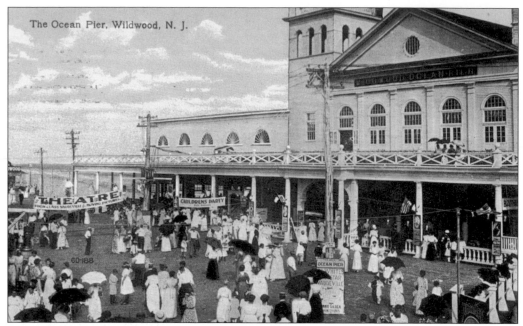

THE OCEAN PIER. Banners and signs in front of the pier advertise upcoming entertainment events as crowds of strollers pass by. Al White's high-class vaudeville show and moving pictures are being publicized. A children's party is to be held in the evening to attract and amuse younger customers. (R.W. Ryan, 1912.)

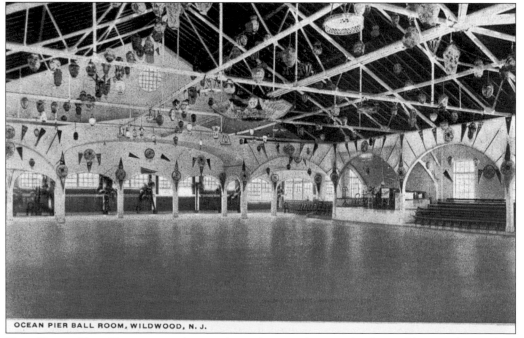

THE OCEAN PIER BALLROOM. Among the main attractions on the Ocean Pier was the spacious ballroom located on the second floor of the main building. Here we see the festively decorated hall, complete with hardwood dance floor and bandstand. Many nights saw this room filled with couples enjoying themselves by dancing the evening hours away. (John C. Funck, *c.* 1920.)

THE PROFESSOR WITH BEANS. Prof. Harry W. Roselle, originally of the Casino, was hired as dancing master of Ocean Pier in 1905. Two years later, he was also managing its roller-skating rink. Roselle often performed with his dog Beans, who became known as the Ocean Pier Dog. Beans was a favorite with the children, who loved to see him perform a variety of stunts. (Wildwood Post Card Company, 1906.)

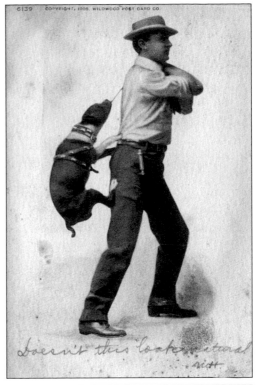

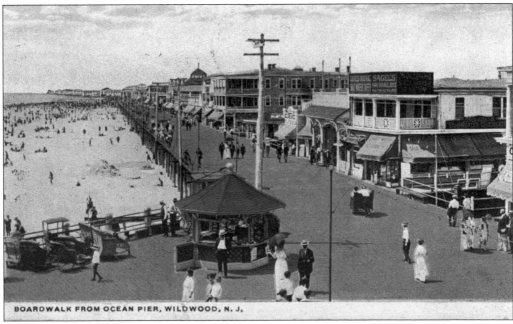

BOARDWALK FROM OCEAN PIER, WILDWOOD, N. J.

THE ROLLING CHAIRS. Just as in Atlantic City, wicker rolling chairs were a common sight on the boardwalk. For a small hourly fee, patrons could sit back and relax while being pushed along the boards at a leisurely pace. Here, in front of Ocean Pier, several rolling chairs await passengers. After decades of use, these chairs disappeared with the arrival of motorized trams in 1949. (John C. Funck, c. 1920.)

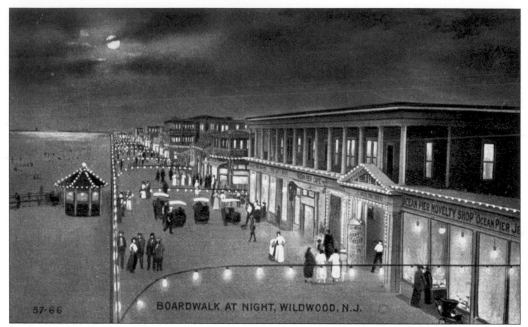

THE BOARDWALK AT NIGHT. Strands of electric light bulbs, strung along and over the boardwalk, light up the promenade. A new feeling of excitement takes over once day turns to night. Down the boardwalk, several rolling chairs are seen transporting their patrons. (R.W. Ryan, *c.* 1914.)

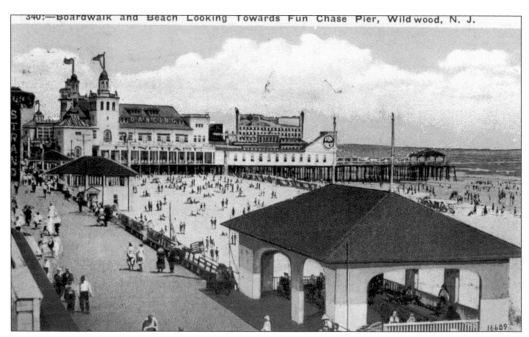

THE BOARDWALK, LOOKING TOWARD FUNCHASE PIER. The electrified sign marking the site of the Strand Theatre is seen on the left of this view. This was one of 17 movie theaters owned by Bill Hunt in 1922. Destroyed by fire in 1944, it was rebuilt in time for the 1947 season. On the right is a large pavilion where boardwalk strollers could stop and rest. (Lynn H. Boyer, *c.* 1923.)

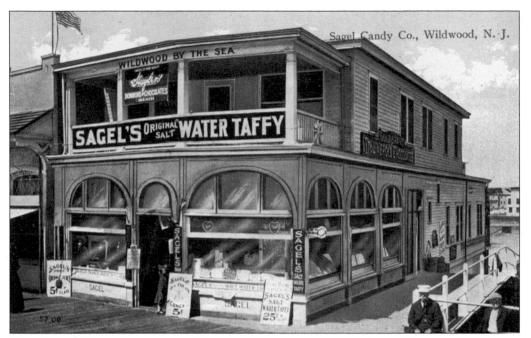

THE SAGEL CANDY COMPANY. No trip to the shore was complete without a taste of New Jersey's most famous confection, saltwater taffy. Sagel's, located at Poplar Avenue and the boardwalk, offered original, saltwater taffy for 25¢ per pound. Signs also advertise ice-cream cones and glasses of orange juice for 5¢ each. (R.W. Ryan, *c.* 1914.)

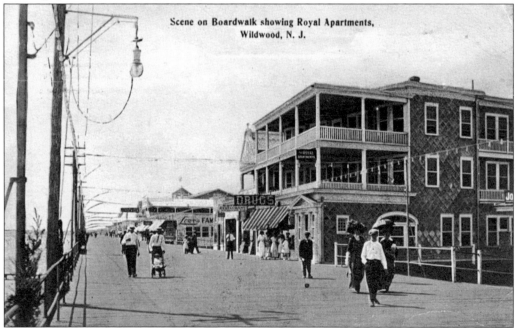

A SCENE ON THE BOARDWALK. Several people are seen enjoying a relaxed daytime stroll at Magnolia Avenue and the boardwalk. The Royal Apartments, viewed on the right, provided rooms for vacationers wishing accommodations close to the ocean and the excitement of the boardwalk. (Post Card Distribution Company, *c.* 1913.)

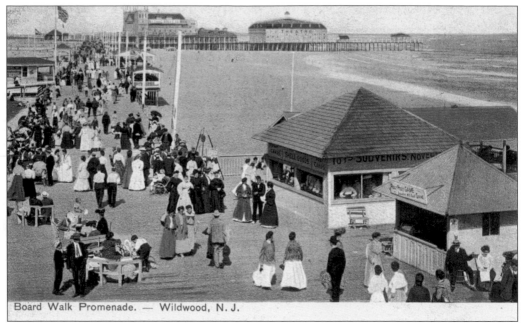

Board Walk Promenade. — Wildwood, N. J.

THE PROMENADE. This boardwalk view looks north toward the Ocean Pier and Ocean Pier Theater in the distance. People stroll by two kiosks in the foreground. The smaller one offers the Roly Poly Game and promises a souvenir with every game. Next to it is a souvenir and novelty stand featuring shell goods. (Wildwood Post Card Company, *c.* 1908.)

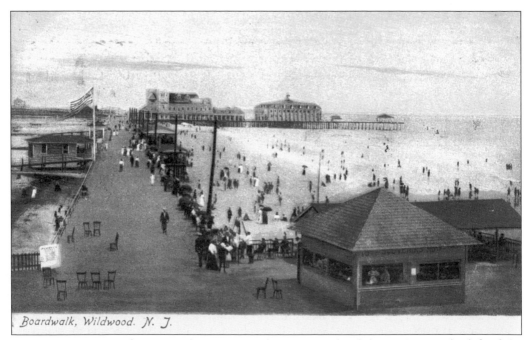

Boardwalk, Wildwood. N. J.

THE BOARDWALK. This postcard image was taken just north of the Casino. To the left of the souvenir kiosk, some people have been attracted to a "guess your weight" man. This individual would attempt, for a small fee, to guess a person's weight within a few pounds. Should he be incorrect, the person won a small prize. (Illustrated Postal Card Company, *c.* 1906.)

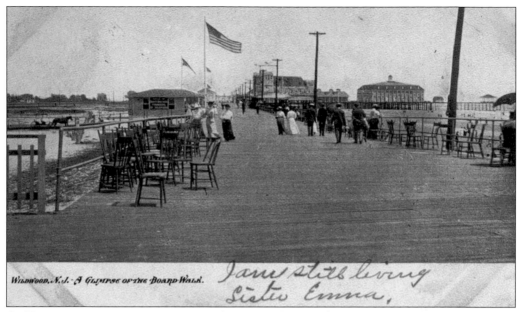

Wildwood, N.J. - A Glimpse of the Board Walk. *I am still living Sister Emma,*

A Glimpse of the Boardwalk. This postcard view shows us the same location from a different perspective than the last photograph. Some ordinary-backed chairs have been placed here so people can stop, sit, and take a break from strolling the boards. Taking a seat by the rail would allow a person to observe the people enjoying the beach below. (World Post Card Company, *c.* 1906.)

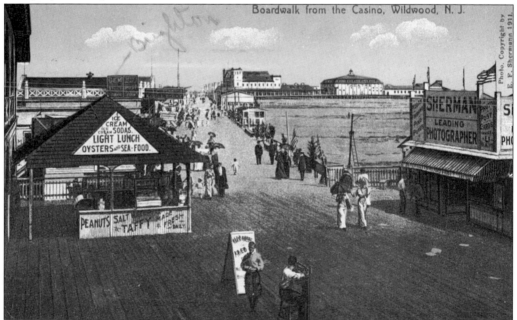

The Boardwalk from the Casino. This same site, in later years, became the location of Sherman's Photography Studio. Here, people could walk in and have personal portrait postcards made while they waited. They could then send or perhaps keep them as a souvenir of their stay in Wildwood. Across from the studio is a refreshment stand offering everything from saltwater taffy and peanuts to light seafood lunches. (R.W. Ryan, *c.* 1911.)

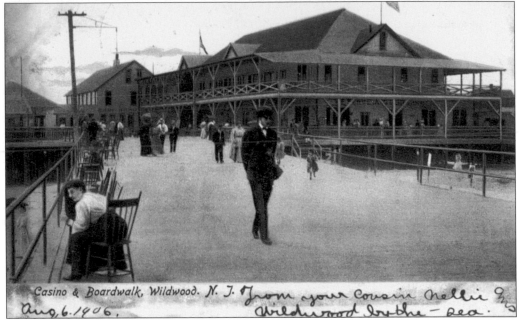

Casino & Boardwalk, Wildwood. N. J. *From your cousin Nellie*
Aug. 6. 1906. *wildwood by the - sea.*

A VIEW OF THE CASINO. The original Wildwood Casino was built in 1897. Over the years, it offered the public a wide range of entertainment choices. From exhibitions of giant sea turtles and sharks to dancing, bowling, weekday afternoon children's parties, and a long fishing pier extending into the sea, people could always depend on the Wildwood Casino to provide new and exciting diversions. (Illustrated Postal Card Company, *c.* 1906.)

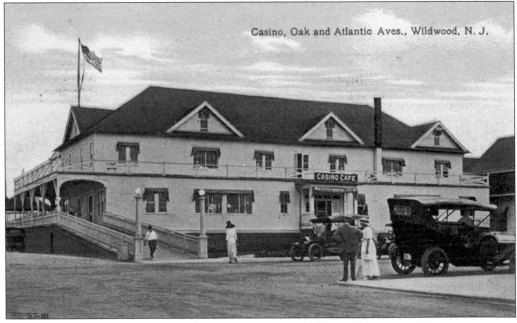

Casino, Oak and Atlantic Aves., Wildwood, N. J.

THE CASINO. Situated at Oak and Atlantic Avenues, the Wildwood Casino and its pier continued to entertain and delight its patrons for decades. This postcard image presents a good view from the street-side entrance to the Casino Cafe. Eventually, the Wildwood Casino was to suffer fire damage in the 1930s. (R.W. Ryan, *c.* 1914.)

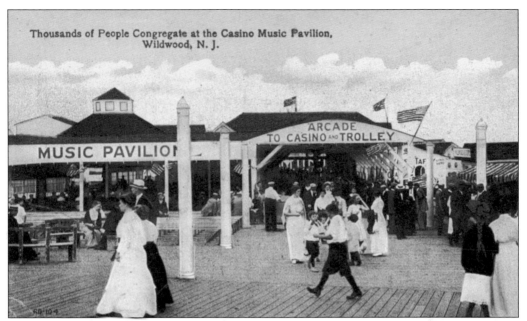

Thousands of People Congregate at the Casino Music Pavilion, Wildwood, N. J.

MUSIC PAVILION

ARCADE TO CASINO AND TROLLEY

THE CASINO MUSIC PAVILION. Seen from the boardwalk is the entrance to the Arcade and Music Pavilion. The Pavilion provided musical entertainment ranging from opera singers to vaudeville and even sacred music performances on Sundays. In view behind the Pavilion is the top of the carousel building, built in 1906. The Arcade was constructed in 1911 to connect the Casino to the boardwalk, which had been moved eastward. (R. W. Ryan, 1912.)

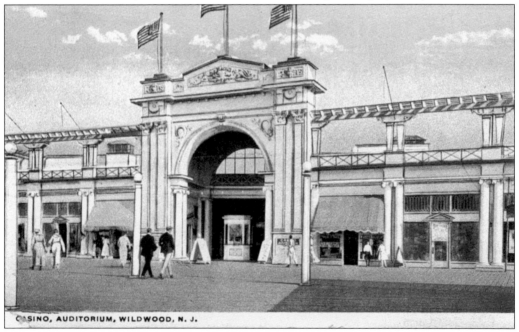

CASINO, AUDITORIUM, WILDWOOD, N. J.

THE CASINO AUDITORIUM. The prominent entrance to the auditorium made it easy to find on the boardwalk. This magnificent hall provided a large seating capacity to accommodate the audiences that came to see and hear performances, which included orchestral concerts and appearances by noted singers of the day. (John C. Funck, c. 1920.)

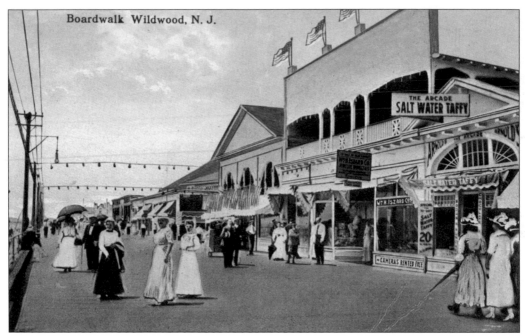

Boardwalk Wildwood, N. J.

ISZARD'S. Next to Arnold's Arcade Saltwater Taffy store was William H. Iszard's jewelry and novelty store. Here, customers could get free rental of a camera, which they could use to capture photographic memories of their visit to Wildwood. Iszard was a local publisher of postcard views, and this particular postcard is one of his. (William H. Iszard, *c.* 1912.)

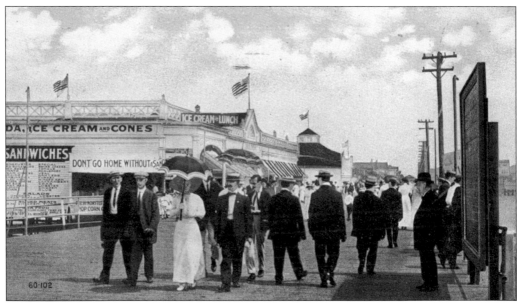

OAK AVENUE. While strolling the boards on a warm sunny day, boardwalk goers such as these might wish to stop and enjoy some cool, refreshing ice cream. Establishments such as this one on Oak Avenue would offer ice cream, popcorn, soda, and a variety of sandwiches to hungry patrons. (R.W. Ryan, 1912.)

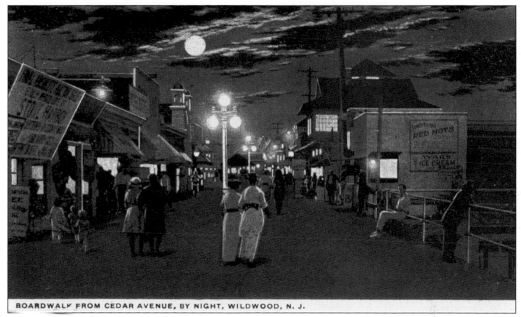

BOARDWALK FROM CEDAR AVENUE, BY NIGHT, WILDWOOD, N. J.

THE BOARDWALK FROM CEDAR AVENUE. At night, the boardwalk takes on an entirely different ambiance as electric lights brighten the thoroughfare. Although nothing like today's colorful, glowing neon lights, the illumination provided during the 1920s, and even earlier, ensured that excitement and entertainment would last long into the evening hours. (John C. Funck, *c.* 1920.)

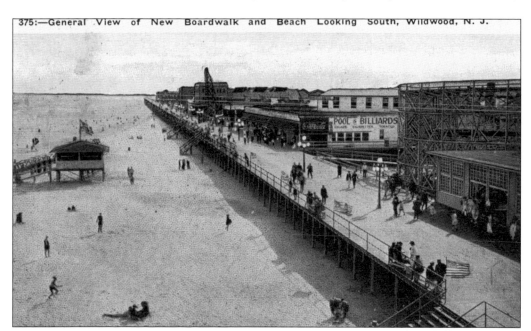

375:—General View of New Boardwalk and Beach Looking South, Wildwood, N. J.

THE NEW BOARDWALK. It was in 1920 that the city commissioner, Oliver Bright, despite opposition, became determined to have the boardwalk moved eastward. One night, he had a large work crew tear up Wildwood's old boardwalk. Even though he lost his job over this action, a new boardwalk was in place by August 1921. It is the new boardwalk that is seen in this postcard view. (Lynn H. Boyer, *c.* 1922.)

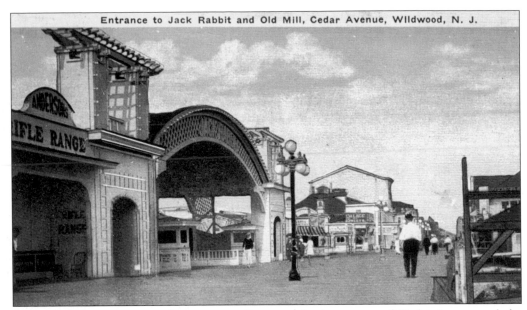

THE ENTRANCE TO THE AMUSEMENT CENTER. At the corner of Cedar Avenue and the boardwalk, amusement park owner Edward E. Rhoads joined with local entrepreneur Gilbert Blaker to convert Blaker's Block into what became known as the Amusement Center. In 1919, the roller coaster named the Jack Rabbit and the popular Ye Old Mill ride were opened to the public. (Publisher unknown, *c.* 1920.)

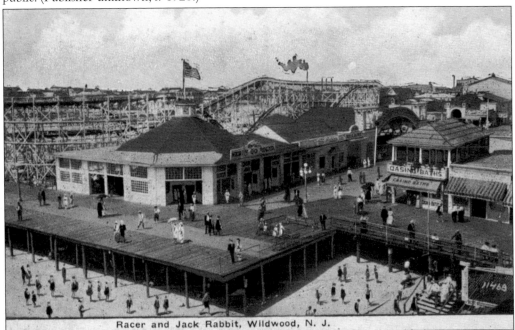

Racer and Jack Rabbit, Wildwood, N. J.

THE RACER AND THE JACK RABBIT. This postcard view shows the corner building housing the Amusement Center's famous merry-go-round. This elegant carousel first began operating during the 1918 summer season. Behind it stands the Jack Rabbit roller coaster, one of the boardwalk's premier thrill rides. In October 1984, these two rides were removed to make way for new development. (L.E. Boyer, *c.* 1920.)

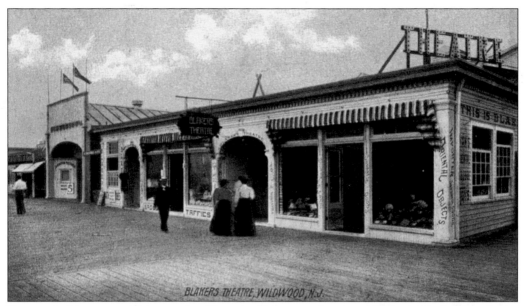

BLAKER'S THEATRE. This stretch of boardwalk became known as Blaker's Block. Here is the entrance to Blaker's Theatre, which was owned by Gil Blaker. Prior to 1918, Blaker was king of Wildwood's amusement enterprises. On the corner is a shop rented to R.W. Ryan (publisher of many of the postcards seen in this book) for his Japanese Bazaar, which featured imported oriental gifts. (R.W. Ryan, *c.* 1906.)

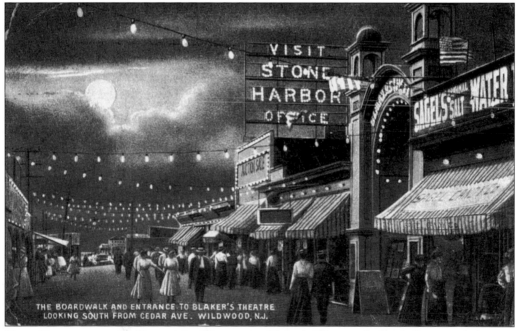

THE ENTRANCE TO BLAKER'S THEATRE. Blaker's Theatre featured live entertainment performed by various theatrical groups. In 1923, this theater would be owned by Bill Hunt, who was, for more than 60 years, one of Wildwood's greatest promoters. A large electric sign advertises the Stone Harbor promotional office, which attempted to interest people in buying property in that resort city north of the Wildwoods. (R.W. Ryan, 1911.)

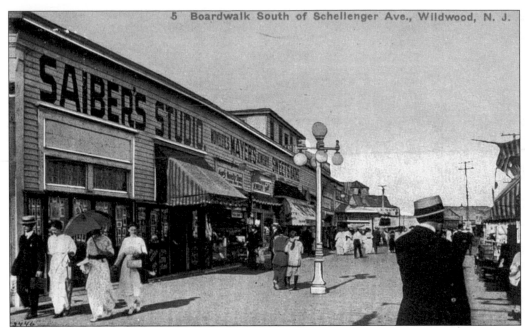

SAIBER'S STUDIO. Just south of Schellenger Avenue on the boardwalk was Saiber's photographic studio. One of several photographers on the boardwalk, Saiber tried to fill the photographic needs of vacationers. Common services provided by Saiber were portrait photographs and real photo postcards that could be made to send to friends and relatives at home. (R.W. Ryan, *c.* 1915.)

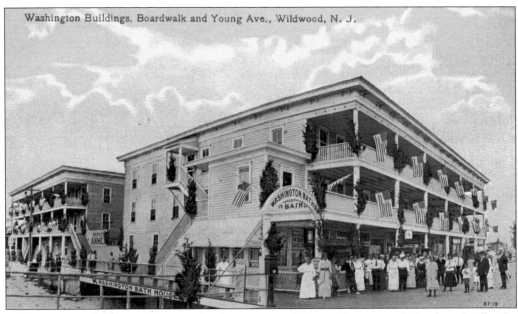

Washington Buildings, Boardwalk and Young Ave., Wildwood, N. J.

THE WASHINGTON BUILDINGS. At the corner of Young Avenue and the boardwalk, the Washington Hotel was open from the end of June until the middle of September. The hotel provided fantastic ocean views, easy beach access, and, of course, the thrill of rooming right on the boardwalk. In 1906, the ocean's high tides came up under the boardwalk at this location. (R.W. Ryan, *c.* 1914.)

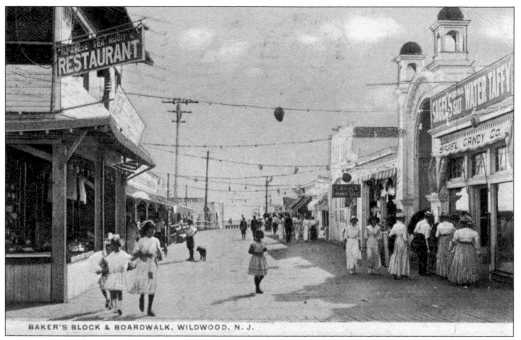

BAKER'S BLOCK & BOARDWALK, WILDWOOD, N.J.

THE BAKER BLOCK. A quiet daytime stroll on the boardwalk takes three young girls past a Japanese tearoom and restaurant. On the opposite side of the "boards," a Sagel's Candy Company store window display attracts the attention of a small group of onlookers. (National Post Card Company, *c.* 1917.)

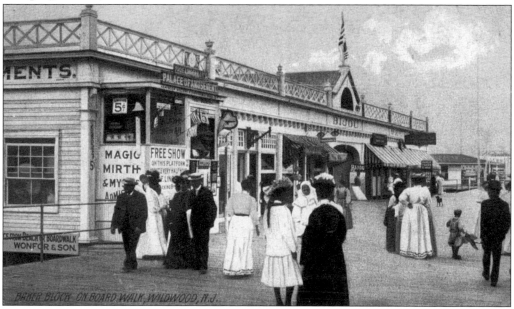

THE PALACE OF AMUSEMENT. Situated on the Baker block of the boardwalk, next to the Bijou Theater, was Prof. Lingerman's Palace of Amusement, opened in 1906. Samuel Lingerman and his wife, Lucy, offered performances of magic and ventriloquism for the admission price of 5¢. To help draw in audiences, they would present a free show about every half hour in front of their establishment. (R.W. Ryan, *c.* 1908.)

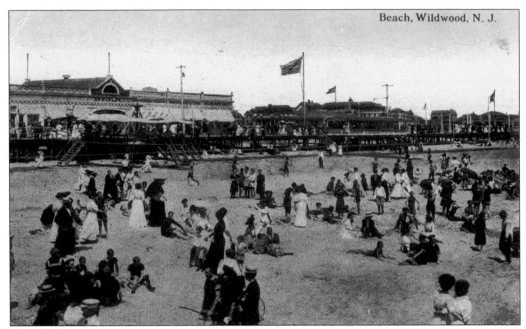

THE BIJOU THEATER. Viewed from the beach is the Bijou Theater, which was situated on the landward side of the boardwalk. Operated by Frank Worden, the Bijou was one of the earliest motion picture exhibitors in Wildwood. Both American and foreign films were shown here to enthusiastic audiences. (George E. Mousley, *c.* 1912.)

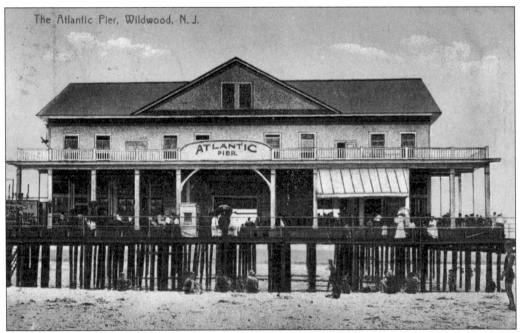

THE ATLANTIC PIER. Constructed in time for the 1910 season, this pier, located at Andrews Avenue, was smaller in size than its rivals and was never able to successfully compete with them. Its attractions included a refreshment center, small concert area, and bathhouse. (R.W. Ryan, 1911.)

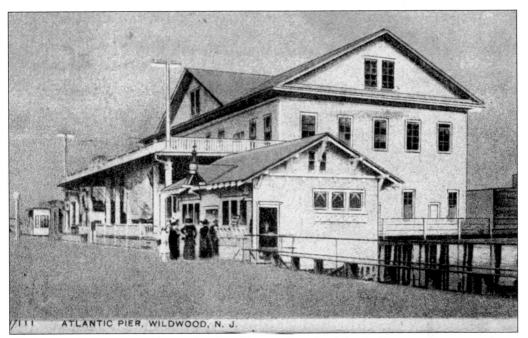

ATLANTIC PIER, WILDWOOD, N. J.

THE ATLANTIC PIER. Within a decade of its opening, the Atlantic Pier stood empty and run down. Attempts were made to renovate the pier in the early 1920s. Even the implementation of year-round boxing matches in 1923 failed to revitalize the facility. The decaying structure was finally torn down in the spring of 1934. (Publisher unknown, *c.* 1916.)

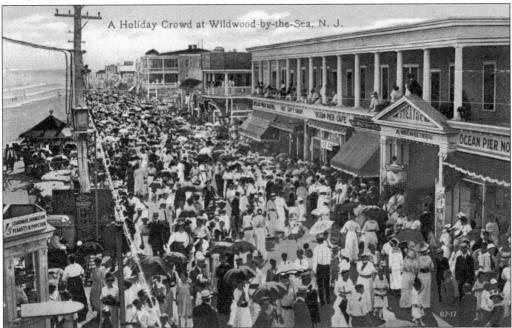

A Holiday Crowd at Wildwood-by-the-Sea, N. J.

A HOLIDAY CROWD. Holidays have always been special occasions at the Wildwoods. If good weather prevailed, the boardwalk could attract enormous crowds, as seen here near Ocean Pier. Memorial Day, the Fourth of July, and the season finale, Labor Day, were exciting times. (R. W. Ryan, 1914.)

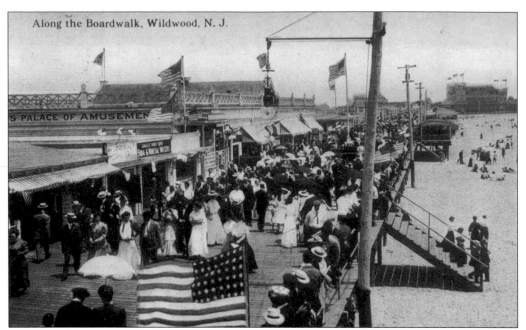

ALONG THE BOARDWALK. Crowds stroll along the boardwalk on the Fourth of July as excitement builds just prior to a scheduled automobile parade. The Fourth of July has always been one of the most popular holiday celebrations in the Wildwoods. (George E. Mousley, *c.* 1910.)

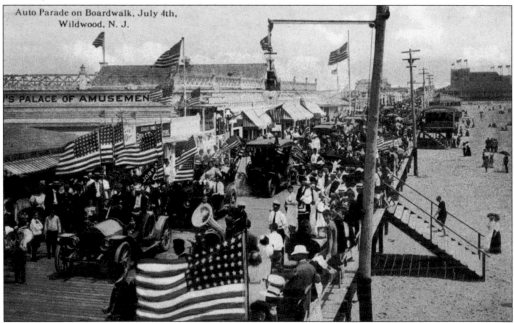

AN AUTO PARADE. During the early 1900s, one of the promotional events used to draw crowds to the boardwalk was an auto parade. This Fourth of July auto parade helped add to the festivities of the holiday. With flags fluttering in the ocean breezes, large numbers of onlookers watch as a long string of automobiles slowly motors down the center of the boardwalk. (George E. Mousley, *c.* 1910.)

102

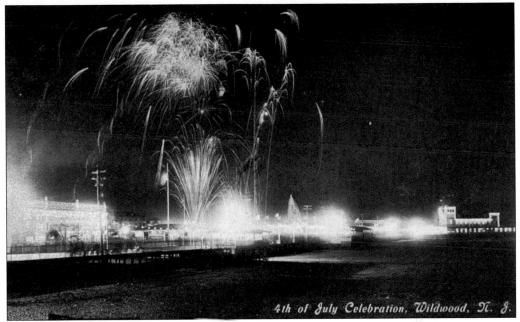

4th of July Celebration, Wildwood, N. J.

A FOURTH OF JULY CELEBRATION. The culminating activity of a Fourth of July observance on the boardwalk was the ever popular fireworks display. Rockets and exploding shells provided a sparkling presentation of radiant color that marked the end of the day's celebration. (George E. Mousley, *c.* 1910.)

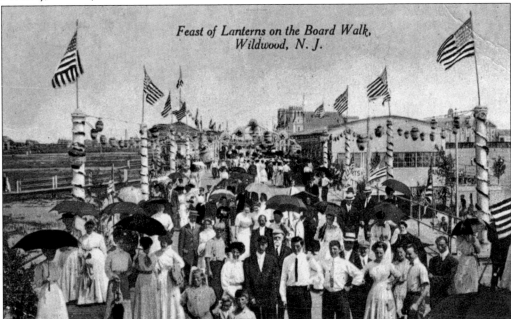

Feast of Lanterns on the Board Walk, Wildwood, N. J.

THE FEAST OF LANTERNS. Thousands of celebrants stroll the boardwalk as they participate in the Feast of the Lanterns. This promotional event was held for several years on Labor Day. It is one of numerous festivals and celebrations that helped draw crowds to the resort. As can be seen in this image, it was quite fashionable for women to carry umbrellas or parasols to shade themselves from the sun. (R.W. Ryan, *c.* 1910.)

103

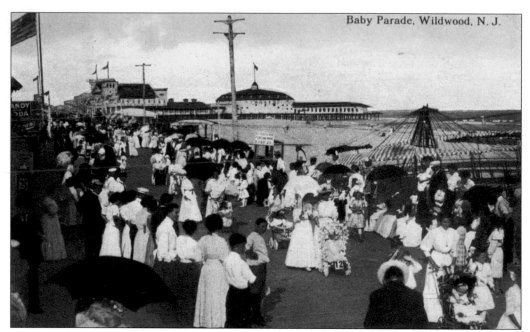

THE ANNUAL BABY PARADE. Started in 1909 by realtor John Ackley as a promotional event, the baby parade would become an annual tradition. Some years, as many as 400 children would be dressed up to take part and compete for prizes. This custom was to last for more than 75 years. (George E. Mousley, *c.* 1910.)

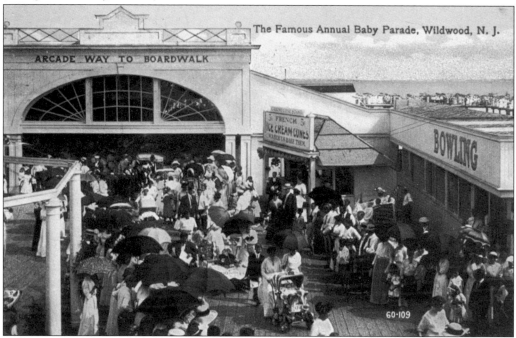

THE BABY PARADE. A procession of participants in the 1912 parade emerges into the sunlight from the Arcade Way to the boardwalk. The babies and infants, dressed up in fancy apparel, are being pushed along in their carriages as groups of spectators look on. The event was for many years the resort's largest annual promotion. (R.W. Ryan, 1912.)

Five

THE BEACH

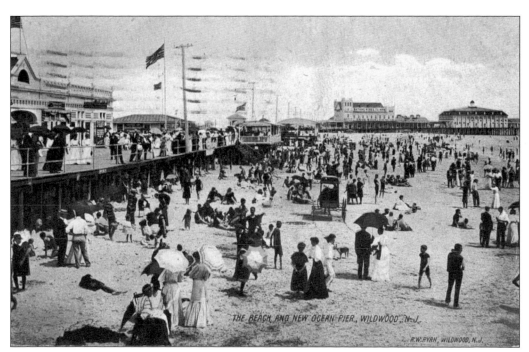

THE BEACH AND THE NEW OCEAN PIER. In the early days of the Wildwoods, the beach was promoted as the place to go to enjoy the health benefits of the sun, sand, and surf. Many generations of beachgoers have left their footprints in the sands of what have often been referred to as the best beaches along the New Jersey coast. (R.W. Ryan, *c.* 1908.)

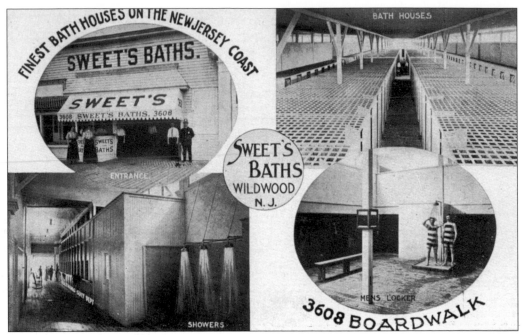

SWEET'S BATHHOUSE. Bathhouses were once common establishments at seaside resorts. They offered people a place to change into their bathing attire or even rent suits for a day on the beach. Hot and cold, freshwater and saltwater showers were usually provided. One of Wildwood's best-known bathhouses was Sweet's Baths, located at 3608 Boardwalk. Opened in 1907, it was destroyed by fire in 1923. (Publisher unknown, c. 1908.)

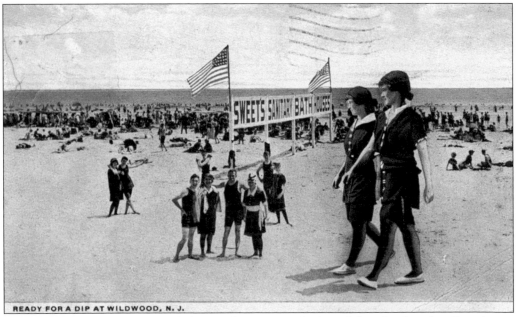

READY FOR A DIP. Two young ladies are shown properly dressed from head to foot for a day on the beach. A large sign advertises "Sweet's Sanitary Bath Houses." One of the largest bathhouses in Wildwood, Sweet's had some 300 changing rooms to accommodate its clients. (Post Card Distribution Company, c. 1919.)

CASINO BATHS. Another of the premier bathhouses was Casino Baths, which boasted of having 350 changing rooms. As part of the Wildwood Casino complex, it could serve thousands of customers per day. Here, we see a young lady dressed in the typical bathing costume of the era. Women's suits consisted of a woolen or flannel bathing dress complemented by high stockings and laced-up surf shoes. (Publisher unknown, *c.* 1905.)

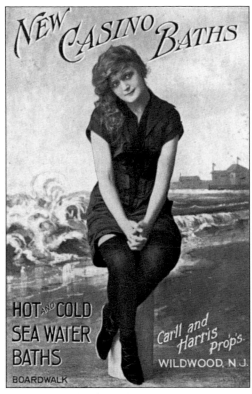

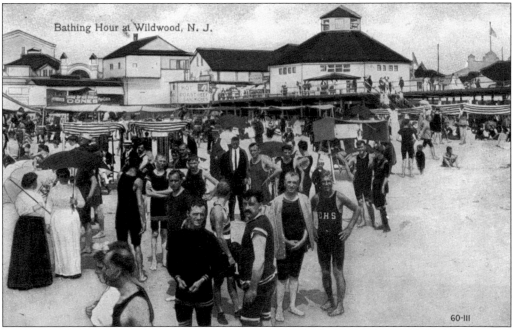

THE BATHING HOUR. While nighttime activity was typically centered around the boardwalk, it was the beaches that ruled the daytime hours. As the beaches began expanding, which they did for some years at a rate of nearly 100 feet per year, it created more space for beachgoers to enjoy the sand and surf. (R.W. Ryan, 1912.)

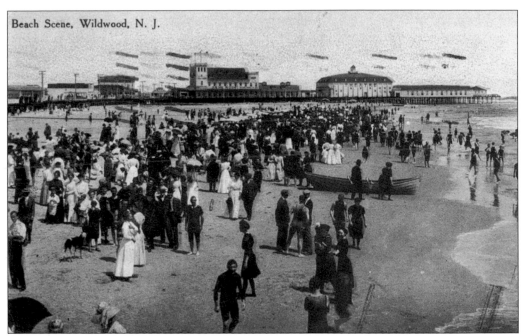

A BEACH SCENE. The beaches of the Wildwoods provided one of the more pleasurable experiences for many summer visitors. As the years passed, the number of beachgoers steadily increased. In 1908, it was estimated that some one million people used the beaches. By 1914, that number had risen to one and a half million. (George E. Mousley, *c.* 1910.)

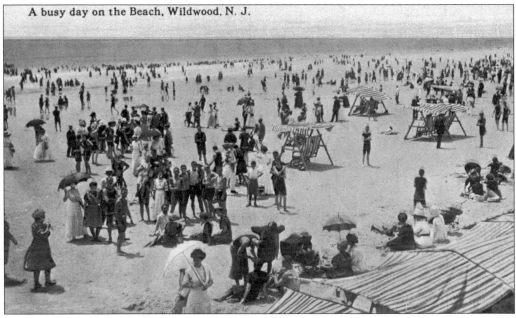

A BUSY DAY ON THE BEACH. Throughout the summer months, the beaches of the Wildwoods were usually crowded with people seeking the enjoyment of the sands and ocean waves. Here, beachgoers stake out a small piece of seaside sand to call their own as they enjoy a day in the sun. (William H. Iszard, *c.* 1915.)

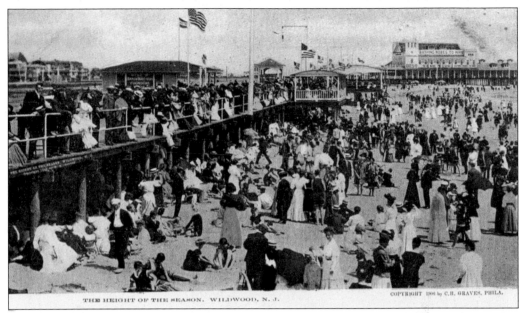

THE HEIGHT OF THE SEASON. Not everyone came to "bathe" in the ocean. In the early part of the 20th century, many came merely to enjoy a stroll or to lounge on the beach while wearing their finest attire. As seen here, people would often line the rails on the boardwalk to gaze at the people enjoying the beach below. (C. Graves, 1906.)

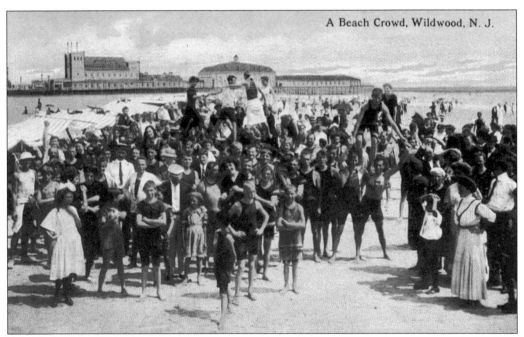

A BEACH CROWD. Some beachgoers stop to pose for the camera while others show off their acrobatic skills. The presence of a photographer on the beach was a surefire way to assemble a crowd. These cameramen helped to preserve a glimpse of what it was like on the beaches during the early part of the century. (George E. Mousley, c. 1912.)

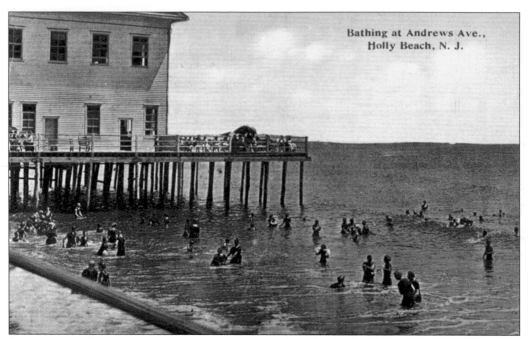

BATHING AT ANDREWS AVENUE. On a pier extending from the boardwalk at Andrews Avenue, people sit and watch as others enjoy the surf below. During the early 1900s, splashing and wading in the ocean was referred to as bathing. Here, the ocean comes right up to the boardwalk. As the years have passed, the beach expanded eastward, creating the widest beaches in the state. (Philip Gould, *c.* 1912.)

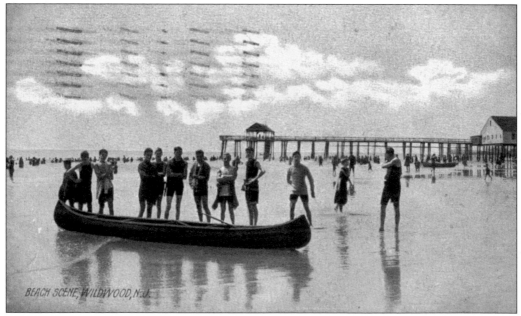

A BEACH SCENE. While others enjoy playing in the surf, these young men gather around a canoe pulled ashore on a beach in Wildwood. Paddling in the waves undoubtedly offered yet another fun-filled activity to engage in while spending the day at the beach. (R.W. Ryan, *c.* 1908.)

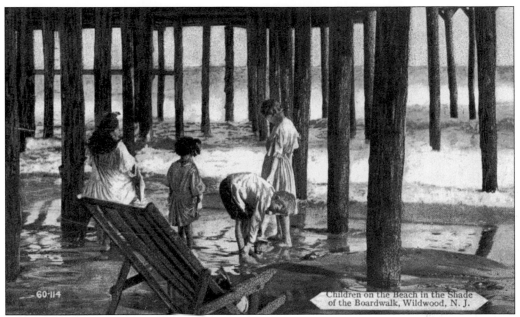

60-114

Children on the Beach in the Shade
of the Boardwalk, Wildwood, N. J.

IN THE SHADE OF THE BOARDWALK. On a hot summer day, the shade of a boardwalk pier could offer a cool spot to enjoy the incoming surf. These charming children, splashing in the water at the ocean's edge, are enjoying one of childhood's greatest pleasures. Notice how completely dressed the youngsters are for playing on the beach. Such beach attire was typical of this era. (R. W. Ryan, c. 1910.)

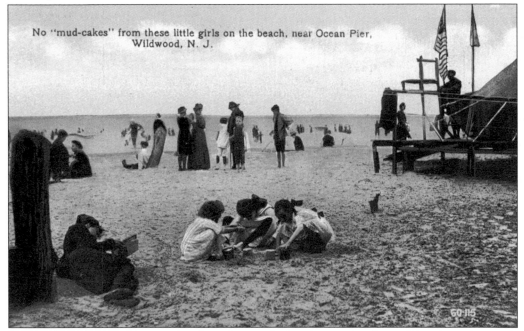

No "mud-cakes" from these little girls on the beach, near Ocean Pier,
Wildwood, N. J.

60-115

NO MUD CAKES. During another busy day on the beach near the Ocean Pier, these three girls seem to be intently involved with molding sand and playing with their sand pails. Nearby, a person taking advantage of the shade produced by a wooden piling appears to be reading a magazine. (R. W. Ryan, 1912.)

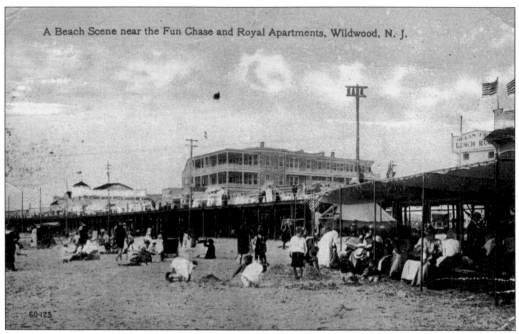

A Beach Scene near the Fun Chase and Royal Apartments, Wildwood, N. J.

A BEACH SCENE. In the shade under a large canopy, some adults sit and enjoy the sea breezes while, in front of them, several children play in the sand. Back on the far side of the boardwalk stand the Royal Apartments, perhaps the lodging place for many of these same individuals. (R.W. Ryan, 1912.)

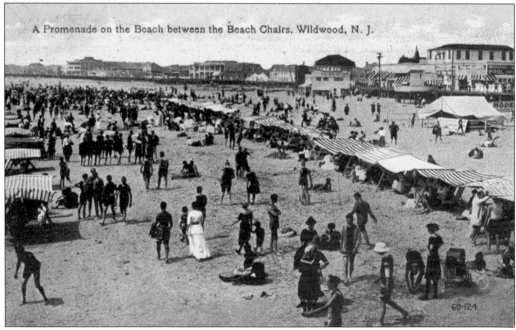

A Promenade on the Beach between the Beach Chairs, Wildwood, N. J.

A PROMENADE ON THE BEACH. This beach scene shows a large number of people enjoying a day on the beach. Shade tents and reclining chairs could be rented to provide shelter from the direct rays of the sun. A large hospital tent set up for the safety of beachgoers is located near the boardwalk. (R.W. Ryan, 1912.)

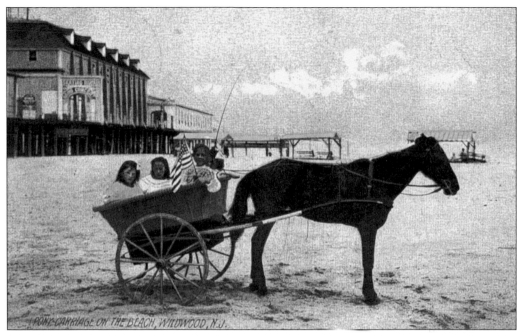

A PONY CARRIAGE. These three young girls have the opportunity to take a delightful ride on the beach in this pony cart. For many years, pony rides and horseback riding was a beach activity of which many took advantage. Behind the girls is the Ocean Pier. (R.W. Ryan, *c.* 1908.)

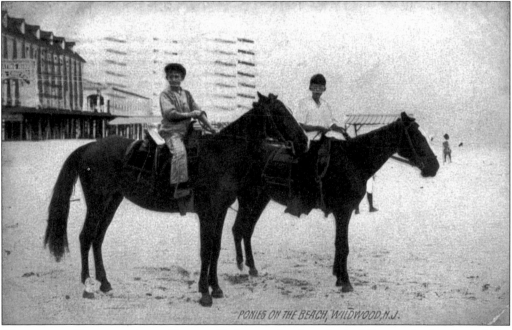

HORSEBACK RIDING ON THE BEACH. Early-morning horseback riding on the beach could be exhilarating and was another popular beach activity. Horses and ponies could be hired out by the hour. Here, two young boys astride their mounts pause to pose for the photographer. Note that this is the same location as the last postcard image. (R.W. Ryan, *c.* 1908.)

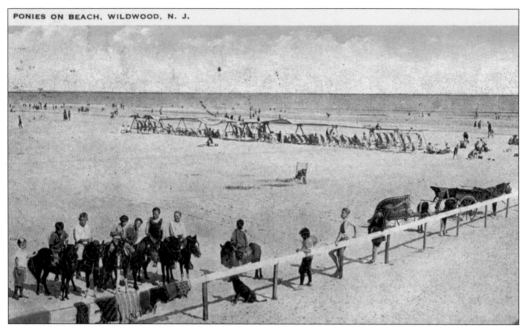

RIDING PONIES ON THE BEACH. This interesting scene shows a group of boys sitting on ponies that were probably rented for a nominal fee. Tied to the railing are ponies hitched to a cart, and even a chariot is present. (Lynn H. Boyer, *c.* 1925.)

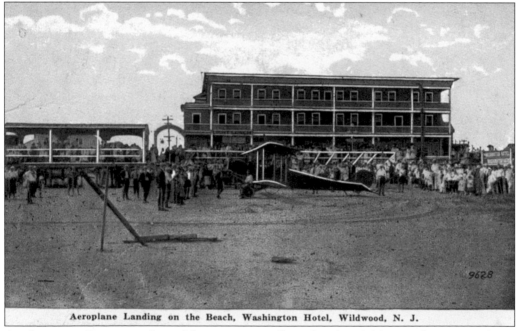

Aeroplane Landing on the Beach, Washington Hotel, Wildwood, N. J.

AN AIRPLANE LANDING. One of the more extraordinary beach activities was the opportunity to take a thrilling airplane ride. Paying customers could take a brief flight aboard this Curtiss JN-4 "Jenny." The plane would take off and land from the beach in front of the Washington Hotel on Young Avenue. Such activity was always sure to draw an audience. (P. Sander, *c.* 1920.)

SHOWING OFF ON THE BEACH. Postmarked July 4, 1910, at Holly Beach, this postcard view shows four young couples showing off for the camera. The beach was an ideal place for boy to meet girl, and many a relationship had its beginnings on the sands of the Wildwoods. (Illustrated Postal Card Company, *c.* 1910.)

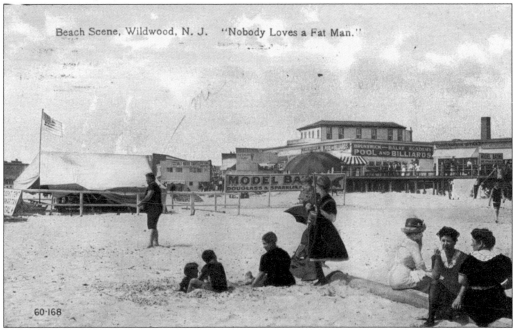

A BEACH SCENE. On the left side of this postcard view, a large hospital tent can be seen. Such tents, erected on the beach and staffed by medical personnel, offered any beachgoer medical assistance, should it be required. These stations helped maintain the public's safety on the beaches. (R.W. Ryan, *c.* 1914.)

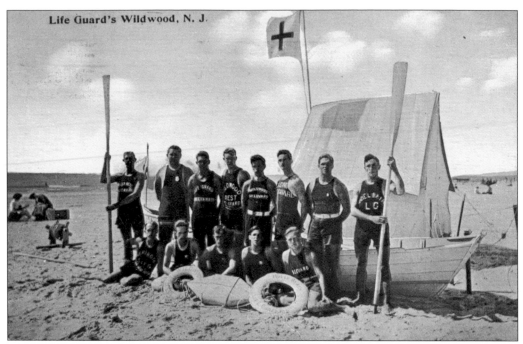

A Group of Lifeguards. During the early 1900s, lifeguards were hired for the summer by individual beachfront hotels and bathhouses. These lifeguards, representing such establishments as Sweet's Baths, the Washington Hotel, and others, are posing with their lifesaving equipment. Such dedicated individuals helped keep the waters safe for swimmers. (John Martin, *c.* 1910.)

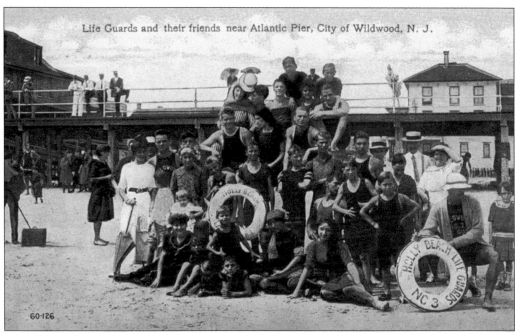

A Group of Lifeguards and Their Friends. Lifeguards have always been popular individuals on the beach. This postcard view shows a group of Holly Beach lifeguards posing with some of their friends on the beach near the Atlantic Pier. (R.W. Ryan, 1912.)

Six

OCEAN, BAY, AND INLET

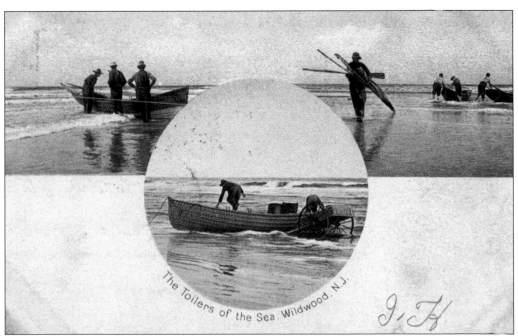

THE TOILERS OF THE SEA. The waters in and around the island of Five Mile Beach have always been of great importance. To some, they have been a place to make a livelihood. Others have used them for recreation, and many have just enjoyed their beauty. These waters, be they ocean, bay, or inlet, are one of the blessings that nature has bestowed upon the Wildwoods. (Wildwood Post Card Company, *c.* 1907.)

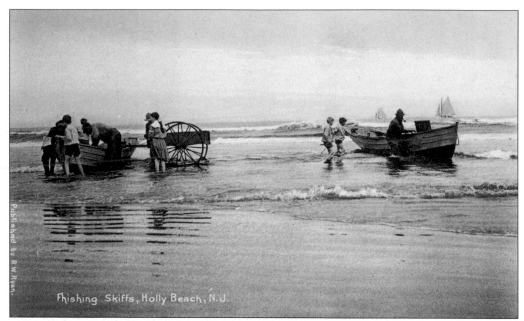

A PAIR OF FISHING SKIFFS. Commercial fishing was an important occupation here during the early 1900s. A number of fishermen actually sailed their skiffs right from the ocean beaches. These fishermen maintained pound nets just offshore to catch a variety of fish species depending on the season. Once ashore, their catch would be loaded into large-wheeled carts to be rolled over the beach to the loading docks. (R.W. Ryan, *c.* 1907.)

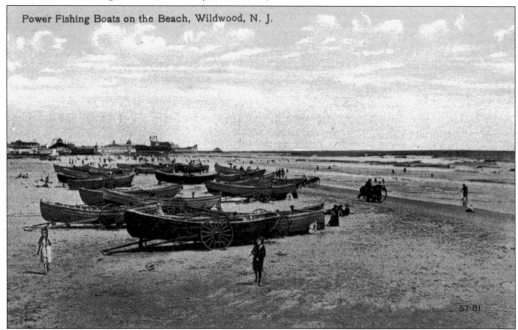

POWER FISHING BOATS. Several fishing skiffs rest on their large-wheeled boat carriages on the beach. The boats were equipped with small engines, which allowed them to motor out to the nearby fishing grounds. As the boardwalk developed and the beaches became more heavily used by bathers, the fishing fleet was to disappear from the sands. (R.W. Ryan, *c.* 1914.)

118

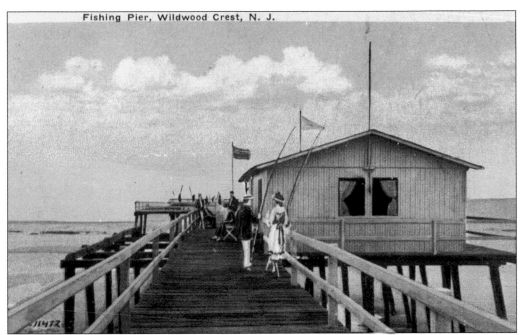

A FISHING PIER. Recreational fishing has also been an important part of the island's life since its early days. Dangling a line from an ocean fishing pier offered anglers the opportunity to fish without having to venture out onto the water. This pier, located in Wildwood Crest, was a popular fishing spot. (Publisher unknown, *c.* 1920.)

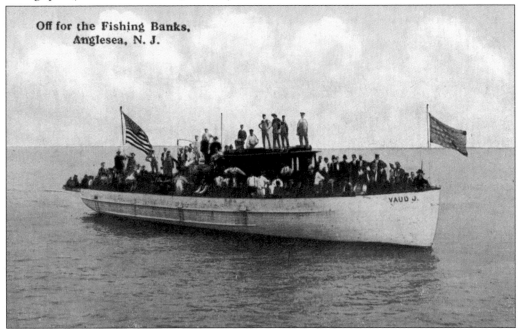

OFF FOR THE FISHING BANKS. Sailing from Anglesea, the vessel *Vaud J.*, seemingly overcrowded, is seen heading for the fishing grounds off the coast. A large number of party boats offered fishermen the chance for a great day of deep-sea fishing. Recreational fishing was so popular that the railroad offered special fishing excursions from Philadelphia. (R. W. Ryan, *c.* 1911.)

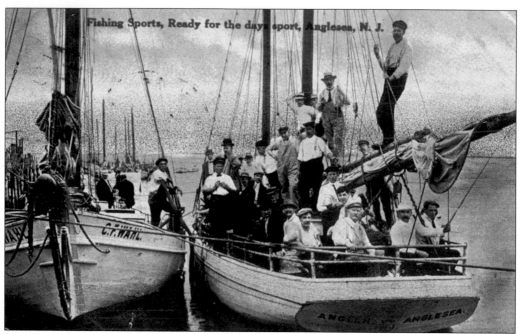

READY FOR THE DAY. Yet another boat from Anglesea makes ready for a day of fishing. This boat took its patrons to the local fishing spots under power of sail. A wide variety of fish species awaited the anglers. Among them were flounder, croakers, sea bass, weakfish, kingfish, porgies, bluefish, and the popular local Cape May goodies. (John Martin, *c.* 1910.)

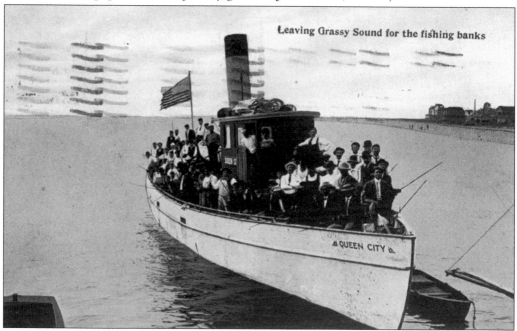

LEAVING GRASSY SOUND. The fishing party boat *Queen City* is shown departing for the fishing grounds. This boat is full of men with their poles and gear eager for a day of angling. Notice that most are dressed in white shirts, ties, and even suit coats. This attire is much different than the clothing worn by modern-day recreational fishermen. (R. W. Ryan, *c.* 1910.)

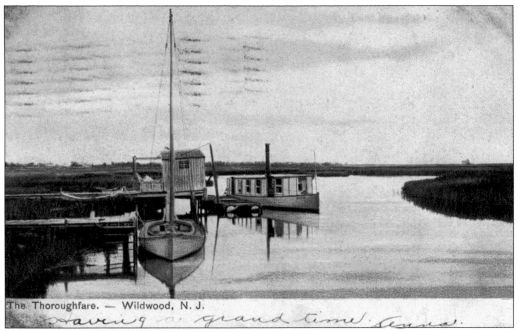

The Thoroughfare. — Wildwood, N. J.

Having a grand time. Jenna.

THE THOROUGHFARE. This is a peaceful scene showing the still waters along the back channels of Grassy Sound. A sailboat and a small steam-powered vessel are tied to their small docks at the end of wooden walkways that cross over the marsh. (Wildwood Post Card Company, *c.* 1908.)

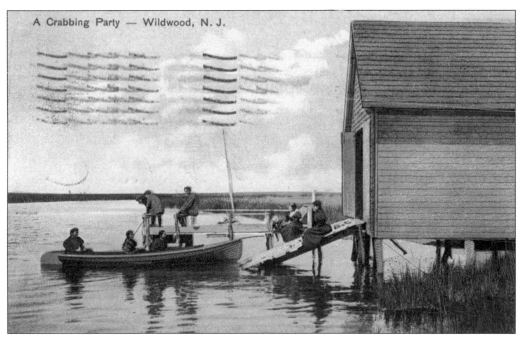

A Crabbing Party — Wildwood, N. J.

A CRABBING PARTY. The sender of this postcard writes, "This is what I will be doing tomorrow, come and join me." Crabbing in the backwaters of Wildwood was and still remains a popular pursuit. Here, people are crabbing from a small dock by a fishing shack on Grassy Sound. (Wildwood Post Card Company, *c.* 1908.)

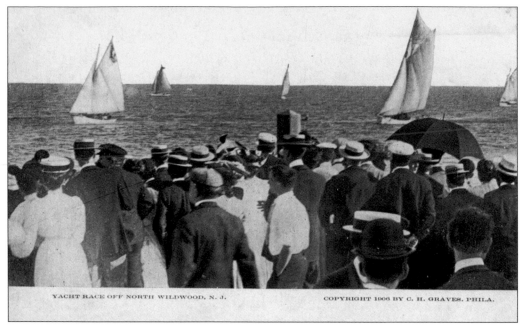

A YACHT RACE. A sunny afternoon boat race attracts a crowd of spectators to the docks in North Wildwood, where they watch as a fleet of sailboats passes by. Sailboat races were quite popular during the early 1900s and were yet another type of diversion for summer vacationers. (C. Graves, 1906.)

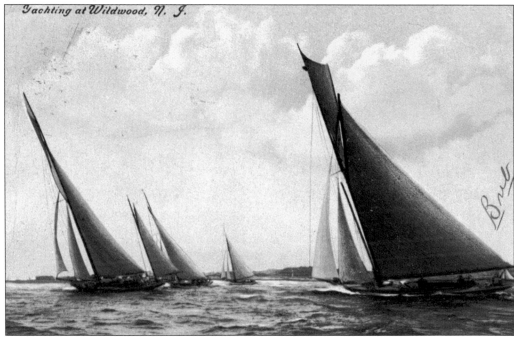

Yachting at Wildwood, N. J.

YACHTING. Yacht races were considered to be a sport of gentlemen. Competitions were periodically held on the waters around the Wildwoods. The fleetness of the boat and the skill of its crew were put to the test as attempts were made to capture the wind in order to speed over the waves. (Illustrated Postal Card Company, c. 1907.)

122

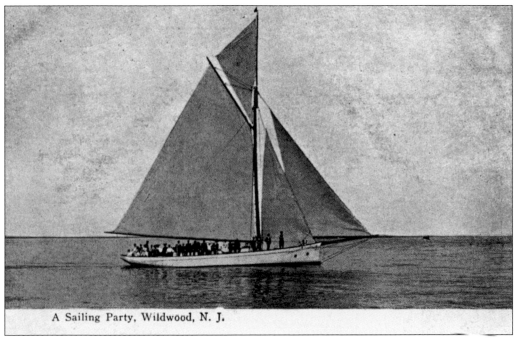

A Sailing Party, Wildwood, N. J.

A SAILING PARTY. A cruise aboard a large single-masted sailing vessel could be an enjoyable way to spend an afternoon. Sailboats such as this one would take paying passengers out to experience a short voyage upon the waters of the bay or ocean. (Publisher unknown, *c.* 1915.)

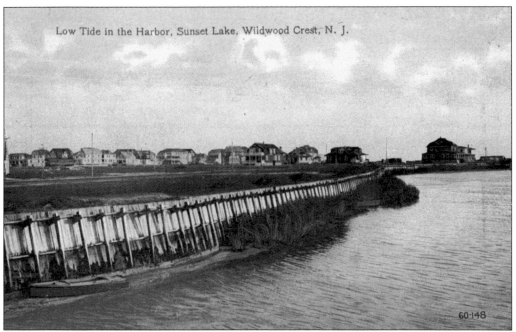

Low Tide in the Harbor, Sunset Lake, Wildwood Crest, N. J.

60-148

SUNSET LAKE. Just to the west of Wildwood Crest lies a body of water known as Sunset Lake. This bay was once connected to the ocean by Turtle Gut Inlet. In 1919, the city engineer, Harry Weir, had the inlet filled in. The result was the connection of the islands of Two Mile Beach and Five Mile Beach, which allowed for the southern expansion of Wildwood Crest. (R. W. Ryan, 1912.)

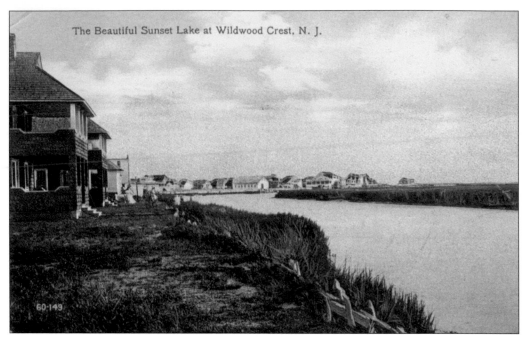

The Beautiful Sunset Lake at Wildwood Crest, N. J.

SUNSET LAKE. This view shows some of the homes built along the banks of Sunset Lake, always a popular location. Families would often gather along the shore of this small bay to witness nature's spectacular display of light and color as the sun set over the water. (R.W. Ryan, 1912.)

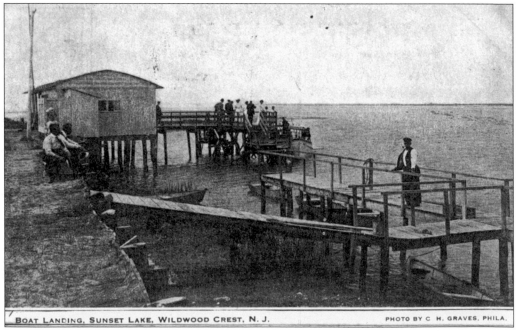

BOAT LANDING, SUNSET LAKE, WILDWOOD CREST, N. J. PHOTO BY C. H. GRAVES. PHILA.

A BOAT LANDING. There were several locations along the shores of Sunset Lake where boat landings were built. Recreational boating on the lake was a favorite activity for many people. Facilities such as this could provide boats for hire or places where people could dock their own. Boating businesses are still active along this shoreline today. (C. Graves, *c.* 1908.)

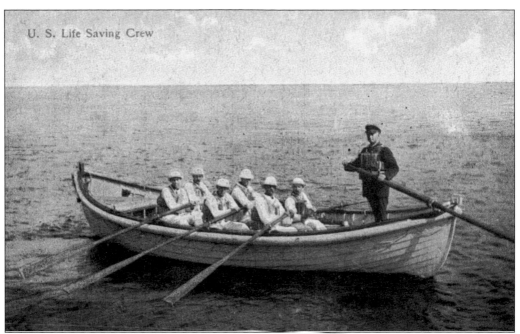

THE U.S. LIFESAVING CREW. The U.S. Lifesaving Service was established in 1848 by Dr. William A. Newell of New Egypt. This organization provided rescue services to those in danger at sea. Stations were set up along the entire East Coast, including Anglesea and Holly Beach. Here, we see a lifesaving crew dressed in their white uniforms, pith helmets, and cork life vests. (Rosin & Company, *c.* 1910.)

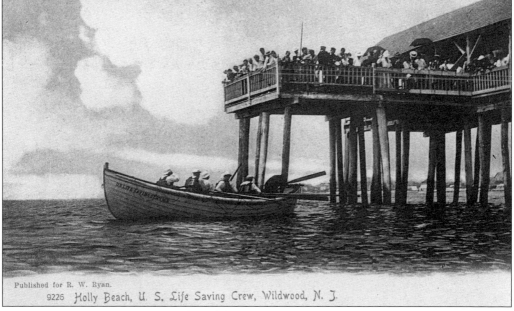

Published for R. W. Ryan.
9226 Holly Beach, U. S. Life Saving Crew, Wildwood, N. J.

A LIFESAVING CREW DRILL. The lifeboat crews of the U.S. Lifesaving Service constantly practiced in order to maintain their proficiency in boat handling. Here, we see a crew of six oarsmen pulling through the surf just in front of the boardwalk. Crowds of spectators would often gather to watch the men go through their drills. (World Post Card Company, *c.* 1910.)

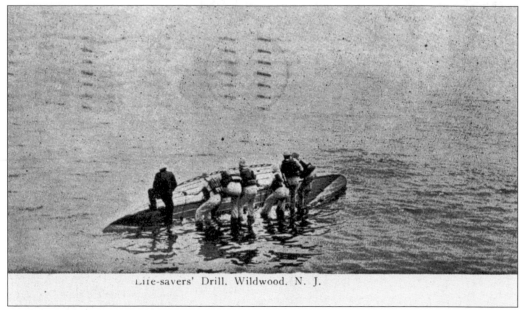

Life-savers' Drill, Wildwood, N. J.

A LIFESAVER'S DRILL. Among the training exercises routinely engaged in by the lifesaving crews were morning capsizing drills such as this one. These drills were very necessary, as rescue work would most likely have to be carried out in foul weather and rough seas. (Publisher unknown, c. 1908.)

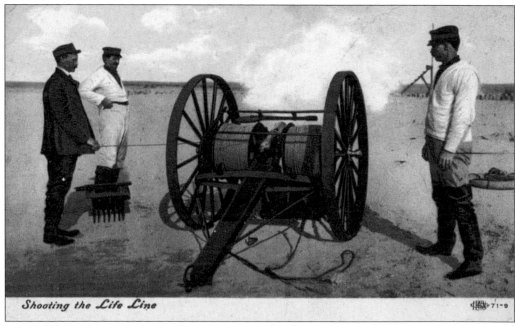

Shooting the Life Line

SHOOTING THE LIFELINE. The U.S. Lifesaving Service had several types of lifesaving equipment at its disposal to help ensure the safety of those who ventured out on the ocean, bay, or inlet. One such piece of apparatus, available at some stations, was a device that was essentially a small cannon for firing a lifeline to people in danger. (Illustrated Postal Card Company, c. 1906.)

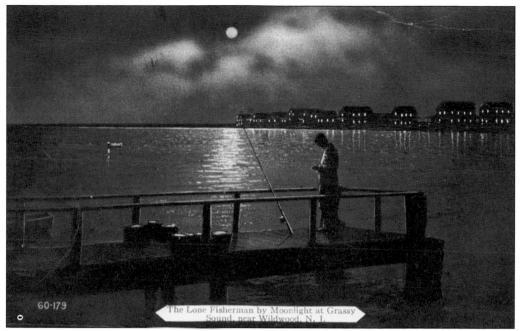

60-179

The Lone Fisherman by Moonlight at Grassy Sound, near Wildwood, N. J.

THE LONE FISHERMAN. As portrayed on this postcard, fishing can be a time of quiet and solitude. A lone fisherman baits his hook as a full moon illuminates the tranquil waters of Grassy Sound. One wonders if he was successful in hooking a catch on this peaceful evening. (R.W. Ryan, 1912.)

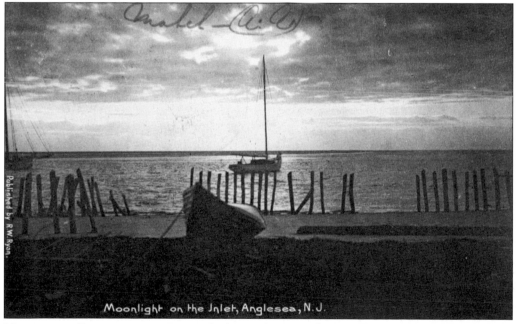

Published by R.W. Ryan.

Moonlight on the Inlet, Anglesea, N.J.

MOONLIGHT SHINES ON THE INLET. At the northern tip of Five Mile Beach Island, a picturesque scene is produced as moonlight shines on the peaceful waters of Hereford Inlet. Tomorrow, the sun will rise, a new day will begin, and the Wildwoods will move forward into the future. (R.W. Ryan, *c.* 1906.)

ACKNOWLEDGMENTS

In undertaking the writing of this book, I was fortunate enough to have the assistance of a number of people whose contributions I would like to acknowledge.

I owe a deep debt of gratitude to the Wildwood Historical Society Museum, located at 3907 Pacific Avenue in Wildwood. Its many fascinating exhibits and excellent reference materials were invaluable to my research. The curator of the museum, Robert J. Scully Sr., generously volunteered to write the foreword for this book and gave freely of his time and expertise. His assistance in this project is most highly appreciated. Very special thanks also to Bob Bright Jr., the museum's manager, who was kind enough to share his vast knowledge of the Wildwoods and patiently guided me in my research. I would also like to make mention of the excellent book *Wildwood by the Sea,* written by David and Diane Francis and Robert J. Scully Sr., and the works of local writer Barbara St. Clair, both of which proved very useful.

Most of all I would like to thank my wife, Debbie, who assisted in my research, proofread the text, and encouraged me in this project.

Lastly, acknowledgment is due to the many photographers and publishers of the postcard views found in this book. Without them, this visual history of the Wildwoods would be incomplete.

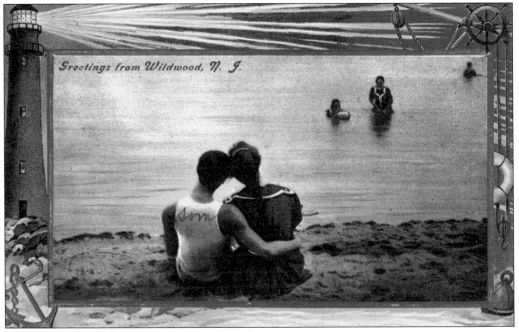

TWO YOUNG LOVERS. Young lovers sit on the beach, gazing out over the calm ocean waters. Perhaps they are remembering the good times they shared here on the New Jersey shore. Or, maybe they are thinking ahead to returning next summer, to once again experience the wonders and pleasures of the Wildwoods. (Publisher unknown, *c.* 1909.)